the best of

1-COLOR

+

2-COLOR

GRAPHICS

ROCKPORT

First published in the United States of America by
Rockport Publishers, a member of
Quayside Publishing Group
33 Commercial Street
Gloucester, Massachusetts 01930-5089
Telephone: (978) 282-9590
Fax: (978) 283-2742
www.rockpub.com

ISBN-13: 978-1-59253-302-2
ISBN-10: 1-59253-302-7

10 9 8 7 6 5 4 3 2 1

Grateful acknowledgment is given to Templin Brink
Design for their work from *Two-Color Graphics*
(Rockport Publishers, 2004) on pages 12–189, and
to Chen Design Associates for their work from
One-Color Graphics (Rockport Publishers, 2002)
on pages 194–345.

Design: chen design associates
 templin brink design
Cover: Dania Davey

Printed in China

the best of

1-COLOR

+

2-COLOR

GRAPHICS

GLOUCESTER MASSACHUSETTS

ROCKPORT PUBLISHERS

chen design associates/
templin brink design

CONTENTS

INTRODUCTION

In a world where so many forms of media vie for our attention—from our littered landscape of billboards to radio and television commercials using over-the-edge tactics to wake us from our numbness just to remember a brand name or a number to "call now!"—it is imperative for us as creative people to strive for integrity in our work and to seek a higher standard for our craft.

It is our hope that this book will become part of our industry's collective reach for excellence. Each piece in the first section was chosen because of its ingenuity, professionalism, and ability to demonstrate the power of design—with the central criterion of having used only one color on press. Non-ink processes such as emboss/deboss, blind hits, foil, die-cuts, and varnishes were acceptable, as were off-press ink techniques such as rubber stamping and laser printing.

Don't be scared of taking on that limited budget—use the restraints of the printing process to liberate your creativity! Read on and be inspired. Let this book be a rejuvenating oasis for your imagination. And the next time that nonprofit or small business you feel utterly passionate about has work to be done, attack the challenge of one-color with confidence. The creative possibilities (or limitations) are what you make them. You may very well discover that the best way to get your corporate client's message across is to reduce their vision of four-color, overproduced gloss to one-color, elegant uniqueness.

Two-color design can be both creatively stimulating and financially liberating. Sure, some designers might shrug their shoulders or snub their noses when a client tells them they can't afford four or more colors. But others rise to the challenge and think beyond the ink. In the second section of this book, we'll show you how we did just that—providing detailed descriptions of how we personally pushed the limits of two-color design. As designers, jurors, and authors of this book, we were hard-pressed to narrow down all the entries we received. So, we settled on work that inspired us and that we hope will inspire you. And, we've included a Color Finder section so you can see the varying impact two colors can make.

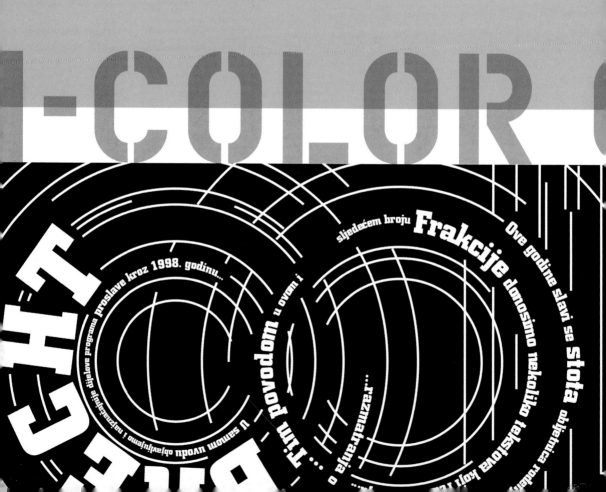

one-color is

striking, distinct, simple, memorable, resourceful, intelligent—and often, ambitious, provocative, beautiful, edgy, jarring, witty, convicted, passionate.

GRAPHICS

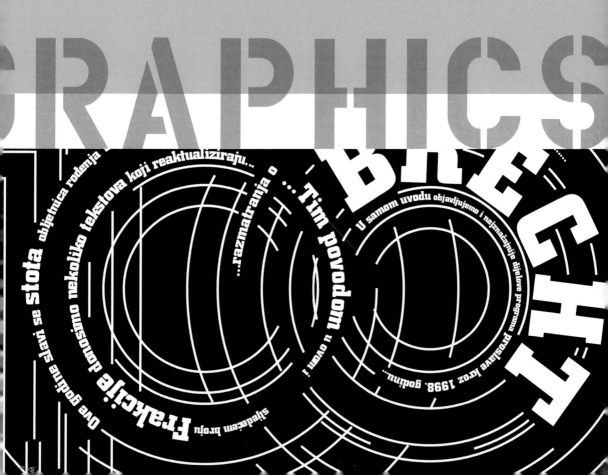

ORIGINS

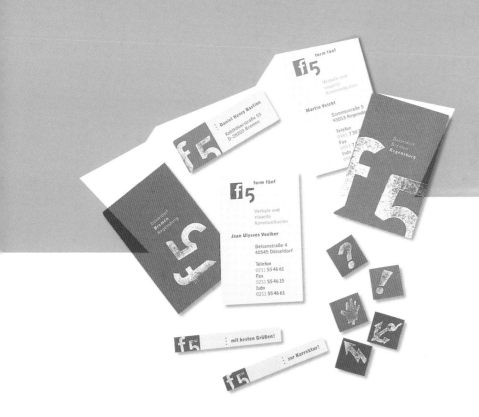

The Core Identity

letterhead / business cards / envelopes / logos

CLIENT. A Day in May Design
ART DIRECTORS/DESIGNERS.
Eve Billig, Lesley Hathaway

TOOLS. QuarkXPress, Illustrator
PAPER. Classic Crest
PRINTING. Full Circle Press

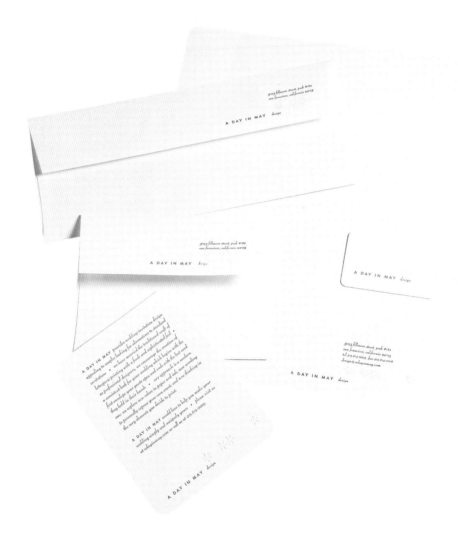

CLIENT. Suzanne George
ART DIRECTOR. Jennifer Jerde
DESIGNERS. Jennifer Jerde, Holly Holmquist, Nathan Durrant

ILLUSTRATOR. Thomas Hennessy
PAPER. Fabriano, Crane's
PRINTING. Dickson's, Inc., Elizabeth Hubbell Studio

★★★Suzanne George identity

Elixir Design

13

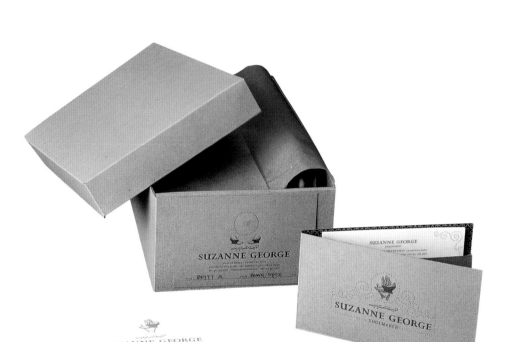

***Freed Arnold Architecture identity
Nassar Design

CLIENT. Freed Arnold Architecture
ART DIRECTOR. Nelida Nassar
DESIGNER. Margarita Encomienda

TOOL. QuarkXPress
PAPER. Neenah UltraWhite, Curious
PRINTING. Offset

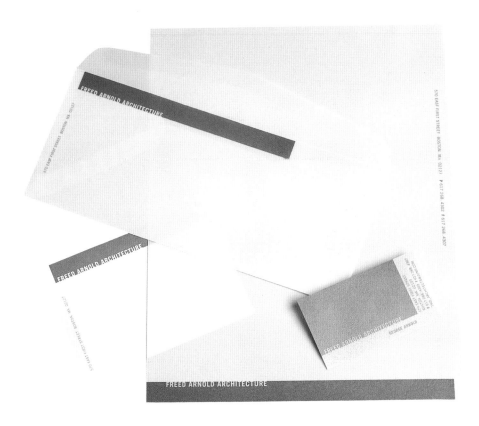

**

BORDERS REWARDS
MEMBERS ONLY

SAVE 30% OFF
List Price of
One Item
Valid at Borders, 3/3 - 3/8/09

POS: Just scan the barcode.

1 5 9 0 4 1 0 9 0 0 0 0 0 0 0 0 0 9 0 1

coupon cannot be combined with any
other in-store offer, including "Buy 1
Get 1 Half Price" offers. One coupon
per customer. Excludes online & prior
purchases, non-stock special orders,
gift cards, electronics, coupon books,
comics, periodicals, vinyl LP formats,
Rosetta Stone, Smart Box products,
self publishing and digital downloads.
Cannot be used with other coupons or
standard group discounts. Cash value
.01 cent. Not redeemable for cash.
No copies allowed. Other uses
constitute fraud.

**

available March 3

Handle with Care
by Jodi Pic

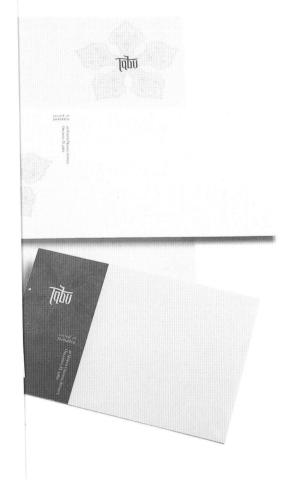

★★★Art Center College of Design Alumni Council logo
Gee & Chung Design

CLIENT. Art Center College of Design Alumni Council
ART DIRECTOR/DESIGNER/ILLUSTRATOR. Earl Gee
TOOLS. Illustrator, Macintosh

CLIENT. Jorge Silvetti
ART DIRECTOR/DESIGNER. Nelida Nassar

TOOLS. Hand typeset
PAPER. Crane Crest
PRINTING. Engraving

Jorge Silvetti

44 Marlborough Street - Boston - Massachusetts 02115

CLIENT. High Watch Farm
ART DIRECTOR. Steve Barretto

DESIGNER. Leonardo Calderón
TOOLS. Illustrator, Macintosh

CLIENT. José J. Dias da S. Junior
DESIGNER. José J. Dias da S. Junior
TOOLS. Corel Draw, PC
PAPER. Color Plus
PRINTING. Offset silver

criação+design

josé j. dias da s. junior
[11] 9603 5022
jjjunior1@ig.com.br

CLIENT. Bruce Carnahan Landscape Design, Inc. **TOOLS.** QuarkXPress, Macintosh
ART DIRECTOR/ILLUSTRATOR. Walter McCord **PAPER.** Mohawk Superfine
DESIGNERS. Walter McCord, Mary Cawein **PRINTING.** Offset lithography

BRUCE CARNAHAN
LANDSCAPE DESIGN INC.

214 ALBANY AVENUE
LOUISVILLE, KENTUCKY 40206
(502) 896-1818

BRUCE CARNAHAN
LANDSCAPE DESIGN INC.

214 ALBANY AVENUE
LOUISVILLE, KENTUCKY 40206

CLIENT. Elixir Design
ART DIRECTOR. Jennifer Jerde
DESIGNERS. Jennifer Jerde, Nathan Durrant

PAPER. Curious Popset
PRINTING. Dickson's, Inc.

★★★Elixir Design identity
Elixir Design

ORIGINS

21

ELXR:DSGN

2134 VAN NESS AVE. SAN FRANCISCO, CA 94109 TEL 415-834-0300 FAX 415-834-0101

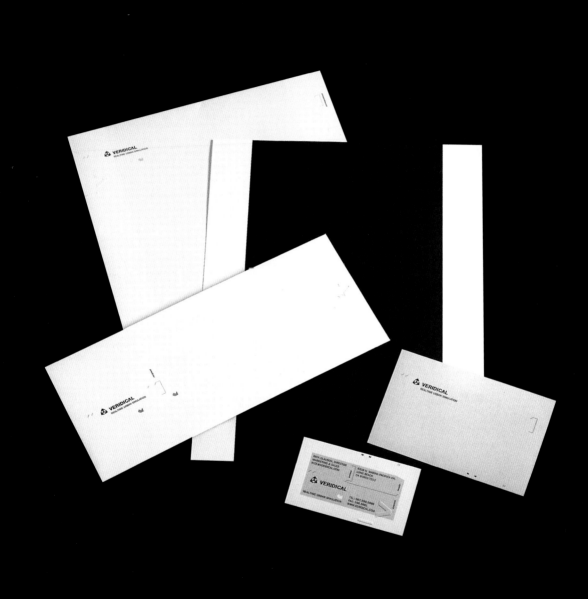

CLIENT. Veridical
ART DIRECTOR. Bill Cahan
DESIGNER. Todd Simmons

TOOLS. Illustrator, QuarkXPress
PAPER. Neenah Classic Crest

★★★Veridical identity
Cahan & Associates

ORIGINS
23

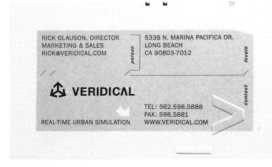

CLIENT. Castor Henig Architecture
ART DIRECTOR. Jennifer Jerde
DESIGNERS. Holly Holmquist, Jennifer Jerde

PAPER. Fabriano (bcard), Crane's (ltrhd)
PRINTING. Dickson's, Inc.

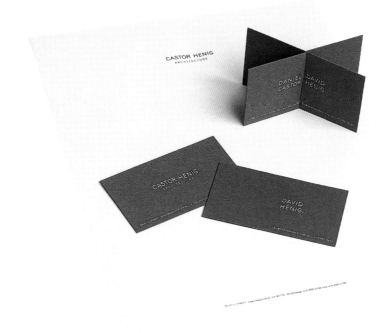

CLIENT. Campion Wines
ART DIRECTOR. Tony Auston
DESIGNER. Don Whelan

ILLUSTRATOR. Mike Gray
TOOLS. Illustrator,
Photoshop, Macintosh

PAPER. Mohawk Superfine
Softwhite
PRINTING. Dickson's, Inc.

★★★Campion Wines identity

Auston Design Group

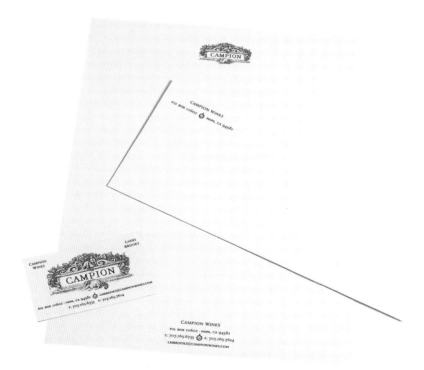

CLIENT. 2001 Dogwood Festival
ART DIRECTOR/DESIGNER. Jeanne Macijowsky
TOOLS. Illustrator, Photoshop

CLIENT. Form Fünf
DESIGNERS. Ulysses Voelker,
 Daniel Bastian, Martin Veicht

TOOLS. QuarkXPress, Fontographer
PAPER. Gohrsmühle Bankpost 100g
PRINTING. Offset lithography

CLIENT. Knoll
ART DIRECTOR. Lynda Decker
DESIGNERS. Lynda Decker, Matt Hamlin

TOOLS. QuarkXPress, Illustrator
PAPER. Strathmore Pinstripe
PRINTING. Dickson's, Inc.

CLIENT. David Elinoff
ART DIRECTOR/DESIGNER.
Aaron Cruse

MATERIALS. Glassine, 16-mm Film
Leader, Player Piano Roll Paper
PRINTING. Silkscreen

★★★David Elinoff business cards
Dead Letter Type

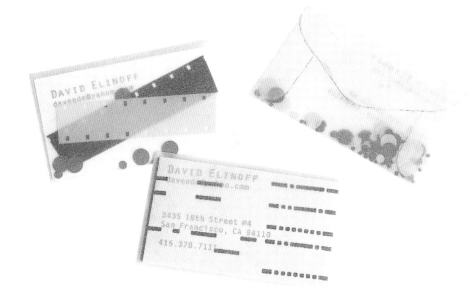

CLIENT. EyeCandyTV.com
ART DIRECTOR. Vanessa Eckstein
DESIGNERS. Vanessa Eckstein, Frances Chen

TOOLS. Illustrator, Macintosh
MATERIALS. Plastic, Chromatica
Transparent, Strathmore
PRINTING. C.J. Graphics

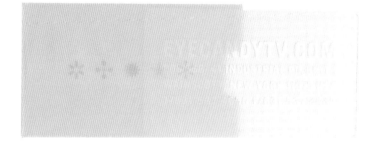

CLIENT. Bowhaus Design Groupe
ART DIRECTOR/DESIGNER. Matt O'Rourke
TOOL. Illustrator

★★★Openhaus logo

Bowhaus Design Groupe

ORIGINS

33

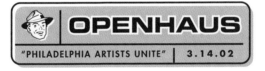

★★★Brophy identity

Drive Communications

CLIENT. Donna Lynn Brophy Photography
ART DIRECTOR. Michael Graziolo
DESIGNERS. Tim Goldman, Michael Graziolo

TOOLS. Illustrator, Photoshop, Macintosh
PAPER. Champion Carnival Yellow (text, cover)
PRINTING. Letterhead and postcard printed
black. Red rubber stamp on all pieces.

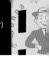

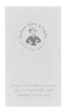

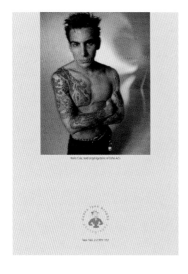

CLIENT. Periwinkle Flowers
ART DIRECTORS. Scott Christie, Kevin Hoch
DESIGNERS. Scott Christie, Erin Boyce

ILLUSTRATOR. Emily Duvervilli
TOOLS. Photoshop, QuarkXPress, Macintosh
PAPER. Plainfield Bright White Smooth
PRINTING. McDougal & Pollard

CLIENT. Richard Seagraves
ART DIRECTOR. Jennifer Jerde
DESIGNER. Jennifer Tolo
PAPER. Crane's
PRINTING. Dickson's, Inc.

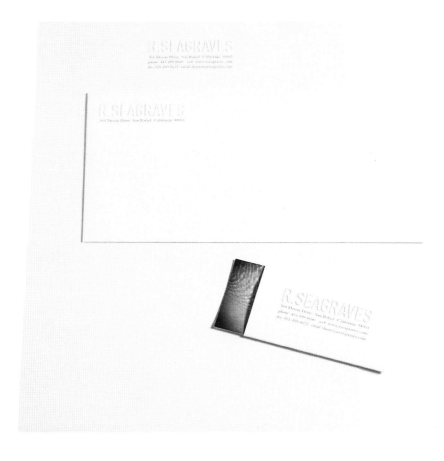

CLIENT. Chara Schreyer
ART DIRECTOR. Karin Myint
TOOL. Illustrator
PAPER. Crane's
PRINTING. Engraving and blind emboss

★★★Chara Schreyer identity
Studio 455

ORIGINS

37

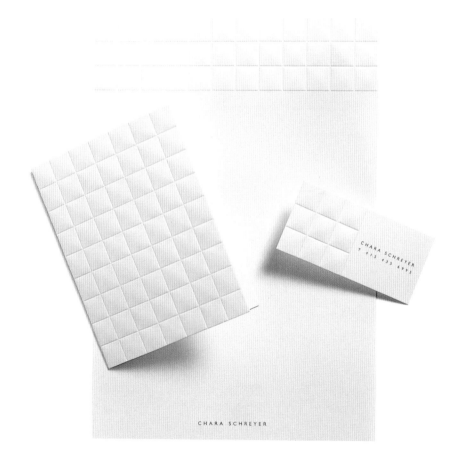

CHARA SCHREYER

CHARA SCHREYER
T 415 435 6995

★★★Framing Amy logo

Becker Design

CLIENT. Framing Amy
DESIGNER. Neil Becker
TOOL. Illustrator

F R A M I N G A M Y

CLIENT. Amy Knapp
ART DIRECTOR/DESIGNER. Amy Knapp
TOOL. Illustrator

PAPER. Crane's Distaff Linen White Wove
(ltrhd, eps); Crane's Pearl White with
Beveled Silver Edges (bcard)
PRINTING. Full Circle Press

★★★Amy Knapp Design identity
Amy Knapp Design

ORIGINS

39

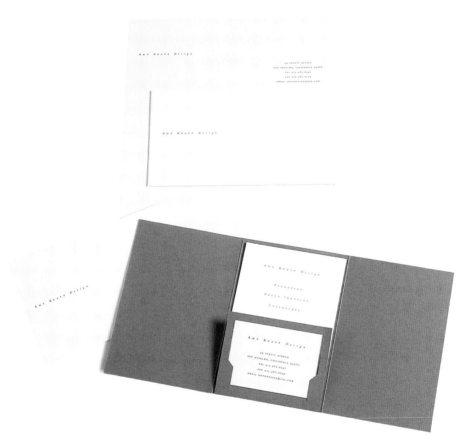

SCION

Collateral Offspring

annual reports / brochures / magazines / campaigns / direct mail / promotions

SCION

CLIENT. Yerba Buena Center for the Arts
ART DIRECTOR. Steve Barretto
DESIGNERS. Vanessa Dina-Barlow, Shilla Mehrafshani

TOOLS. QuarkXPress, Macintosh
PAPER. G-Print Matte Text
PRINTING. Trace Lithography

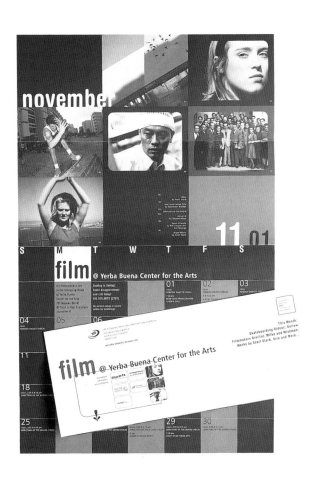

SCION

TOOLS. QuarkXPress, Macintosh
PAPER. G-Print Matte Text
PRINTING. Trade Lithography

CLIENT. Yerba Buena Center for the Arts
ART DIRECTOR. Steve Barretto
DESIGNERS. Vanessa Dina-Barlow, Shilla Mehrafshani

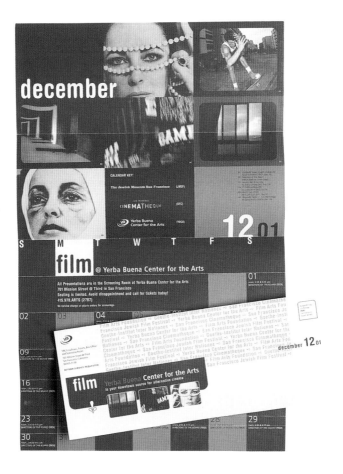

SCION

CLIENT. Ballets Jazz de Montréal

ART DIRECTOR/DESIGNER.
Denis Dulude

PHOTOGRAPHERS. Pol Baril, Nicole Rivelli, Joël Dumoulin

TOOLS. Illustrator, Photoshop, QuarkXPress, Macintosh

PAPER. Conda Supreme

PRINTING. Sheetfed offset

lumière espace temps

La salle et la scène sont plongées dans le noir pendant quelques instants. La scène et l'espace...

Puis, pendant quelques instants, la scène et la salle se reposent dans le noir, vous vous libérez de votre fauteuil, vous émergerez de cette rencontre unique, singulière et pluralle, et vous quitterez une réalité pour entrer dans une autre ... peut-être la vôtre.

Hua Feng Zhang → ...

La maîtresse de ballet ☆ The Ballet Mistress

Hua Feng Zhang → ...

Light—Time—Open Space

For a few moments, darkness engulfs the stage and auditorium...

Again, the stage and auditorium briefly plunge into darkness...

les **BALLETS** *jazz* de Montréal

SPACE **GO**

Directeur artistique
uis Robitaille
Artistic Director

programme

lumière espace temps
Light—Time—Open Space

du **4** au **15** avril 2001
April **4** to **15**, 2001

TRENTE-HUITIÈME ASSEMBLÉE GÉNÉRALE ANNUELLE

RAPPORT ANNUEL
2000–2001
Cinémathèque québécoise

SCION

CLIENT. Cinémathèque Québécoise
ART DIRECTOR/DESIGNER.
Annie Lachapelle

TOOLS. QuarkXPress, Macintosh
PAPER. Bytonic by Spexel/Linen Vanilla
PRINTING. Sheet-fed offset

S60S

2001
RAPPORT D'ACTIVITÉS

FAITS SAILLANTS

IL A BEAUCOUP ÉTÉ QUESTION D'ARGENT À
LA CINÉMATHÈQUE CETTE ANNÉE. JUSQUE SUR
LA PLACE PUBLIQUE. LES FINANCES DE LA
CINÉMATHÈQUE AURONT FAIT L'OBJET D'ARTICLES,
D'OPINIONS ET MÊME DE PÉTITIONS.

LA CINÉMATHÈQUE QUÉBÉCOISE

MEMBRES DU CONSEIL D'ADMINISTRATION
2000-2001

Président

Vice-présidents

Secrétaire

Trésorier

Administrateurs

MESSAGE DU PRÉSIDENT

★★★Orchard Street Market collateral

Love Communications

SCION

CLIENT. Orchard Street Market
ART DIRECTOR. Preston Wood

DESIGNERS. Preston Wood, Amy Veach
ILLUSTRATOR. Scott Greer

TOOLS. Illustrator, QuarkXPress
PAPER. Kraft
PRINTING. DuMac

ORCHARD STREET MARKET

Where freshness is always in season.

ORCHARD STREET MARKET

Where freshness is always in season.

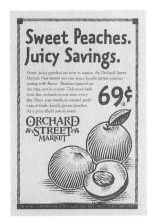

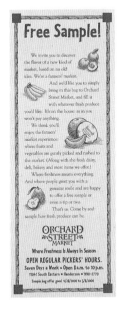

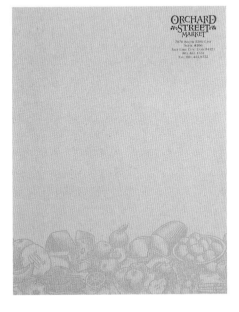

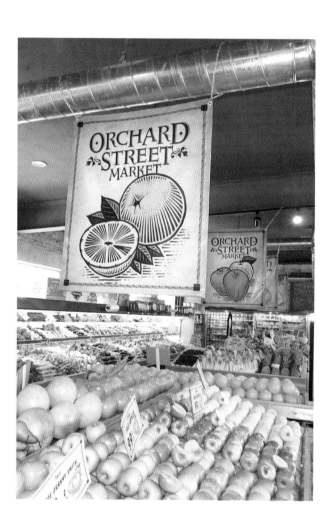

SCION

CLIENT. Target Margin Theater
ART DIRECTOR/DESIGNER. Noah Scalin
ILLUSTRATOR. David Zinn

TOOLS. QuarkXPress, Macintosh
PAPER. Domtar Weeds (text), Domtar Sandpiper (cover)
PRINTING. Offset

ARTIFACTS

This HANSA steeples is one of our most exceptional finds. It appears to be a giant thin mask; a fertility god has been hypothesized.

Beaumarchais' classic contains evidence of radical revolution in the social order and bitter personal heartbreak. Yet joyous festivity in the secular sphere is also present; our team has identified numerous "jokes" as part of a so-called "comic tradition." We feel that this work can only be explained by a keen reversal of power structures amid celebration. But how are we to understand the resolution? This dig has been especially fascinating as a precursor to *Opera Mozartiana.*

ARTIFACTS

The revolutionary comedy that inspired Mozart's great opera. This classic of sexual intrigue and social power shook France in the 18th century, and it will shake New York in 2001.

The Marriage of Figaro

by Pierre Augustin Caron de Beaumarchais
Directed by David Herskovits

Emily Phillips, Scenery
Miranda Hoffman, Costumes
Josh Epstein, Lighting

At The Ohio Theater 66 Wooster Street
(see location a. on the *Supplemental Information Map*)

Previews start Oct. 10
Opening Oct. 17

Reservations 212-358-3657

THE DISCOVERY OF

The Operatic Era

"TARGET MARGIN THEATER
GOES TO THE OPERA"

A SEASON OF THEATRICAL ARCHEOLOGY
AND CREATIVE SCIENCE
2001–2002

SCION

TOOLS. Freehand, Macintosh
PRINTING. Sioux Printing

CLIENT. Su-zen
ART DIRECTOR. Matteo Bologna
DESIGNERS. Andrea Brown, Matteo Bologna

SCION

CLIENT. Identix
ART DIRECTOR. Bill Cahan
DESIGNER. Michael Braley

TOOLS. QuarkXPress, Macintosh
PAPER. 70# Topkote Dull (cover, text)
PRINTING. Lithographix

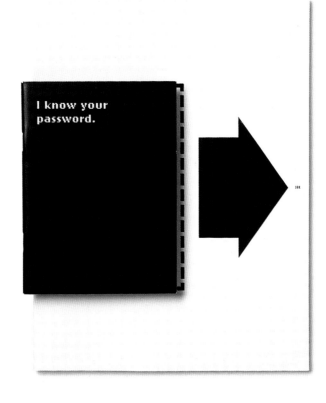

I know your
password.

THE IDENTIX GOAL

To replace the overload of
user ID cards, passwords, PINs,
and other current authentication
methods with something
permanent and convenient
that can never be forgotten,
lost, stolen, forged or broken.
Your fingerprint.

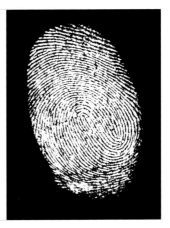

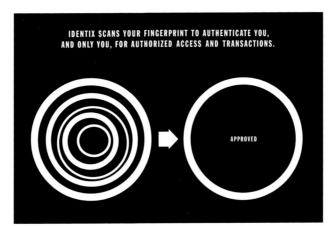

IDENTIX SCANS YOUR FINGERPRINT TO AUTHENTICATE YOU,
AND ONLY YOU, FOR AUTHORIZED ACCESS AND TRANSACTIONS.

APPROVED

IDENTIX BIOMETRICS SOLUTIONS WILL BE INTEGRATED ACROSS ALL ENVIRONMENTS AND MARKETS...

E-COMMERCE

Biometrics will unlock the
potential of e-commerce.
Identix partners KeyTronic and
Compaq provide fingerprint
reader-equipped keyboards
and peripheral devices,
that will deliver high security
for Internet transactions.

NETWORK AND SERVER ACCESS

Identix Biometrics enables
the authorized user to
access restricted networks,
servers, databases, files and
intranets with a single finger,
eradicating password-related
burdens on help desks.

FACILITY ACCESS

Identix physical access
systems secure some of the
most fortified sites, including
military facilities. Identix's
diverse installations range from
armored cars to healthclubs.

AIRPORT SECURITY

Biometrics bolsters airport
security and can deter terrorist
activity. Chicago O'Hare
International Airport uses
Identix authentication for an
array of security programs.

BANKING AND FINANCIAL SERVICES

Through fingerprint authentica-
tion, Identix solutions make
online transactions, account
information and other banking
and financial services more
convenient and more secure.

DATABASE SECURITY

Identix fingerprint authentica-
tion prevents unauthorized
database access and informa-
tion theft. With BioLogon™,
BioShield™ and BioSafe™,
Identix can protect and encrypt
information and applications.

WIRELESS PHONES

Built-in fingerprint sensors will
soon be an option for greater
mobile phone security. Identix
and Motorola have forged a
partnership to build biometrics
into wireless chip architecture.

California College of Arts and Crafts

MFA IN WRITING

CCAC MFA IN WRITING:
where writing and visual art intersect

THE MFA IN WRITING FACULTY INCLUDES
Juvenal Acosta | Betsy Davids | John Laskey | Canyon Sam | Hugh Steinberg | Ann Williams
RECENT VISITING WRITERS HAVE INCLUDED
Rae Armantrout | Anita Barrows | Anne Carson | Andrei Codrescu | Fred Dings
Diane di Prima | Lawrence Ferlinghetti | Thom Gunn | devorah major | David Matlin
Kevin McIlvoy | Randall Potts | Jerome Rothenberg | Cooley Windsor

Set in a thriving art school environment in San Francisco, CCAC's writing program offers
students rare opportunities to collaborate with artists, designers, and other writers.
Our program is designed for writers of fiction, poetry, and scripts, and for
writers working in the developing field of text and image.

CALIFORNIA COLLEGE OF ARTS AND CRAFTS
San Francisco/Oakland Call 1.800.447.1ART (1278)
Art, Architecture, and Design www.ccac-art.edu

58

★★★Frakcija magazine
Igor Masnjak Design

CLIENT. Frakcija, Performing Arts Magazine
ART DIRECTOR/DESIGNER/ILLUSTRATOR. Igor Masnjak

TOOLS. QuarkXPress, Photoshop, Freehand, Macintosh
PAPER. 135g/m² Magnomatt
PRINTING. Offset litho

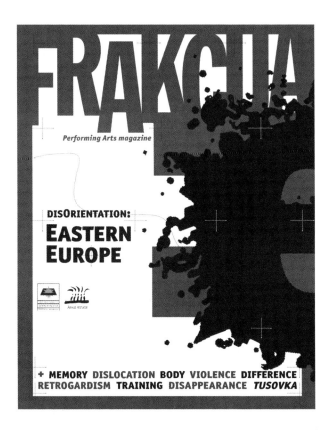

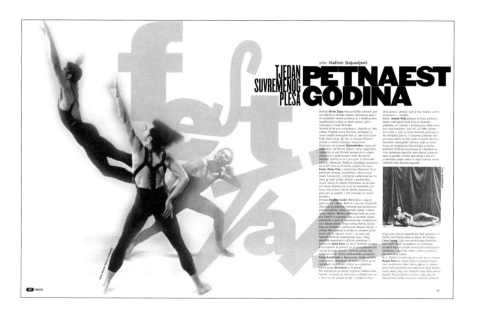

piše: Vladimir Stojsavljević

TJEDAN SUVREMENOG PLESA — PETNAEST GODINA

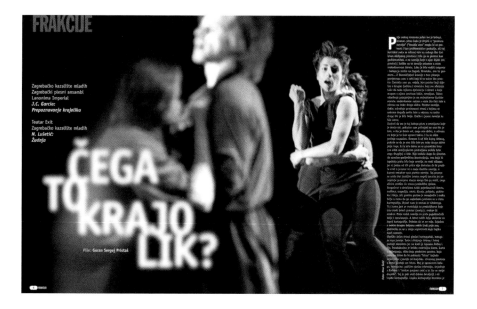

FRAKCIJE

Zagrebačko kazalište mladih
Zagrebački plesni ansambl
Lanonima Imperial
J.C. Garcia:
Prepoznavanje krajolika

Teatar Exit
Zagrebačko kazalište mladih
N. Lusetić:
Žudnja

ČEGA TO KRAJO LIK?

Piše: Goran Sergej Pristaš

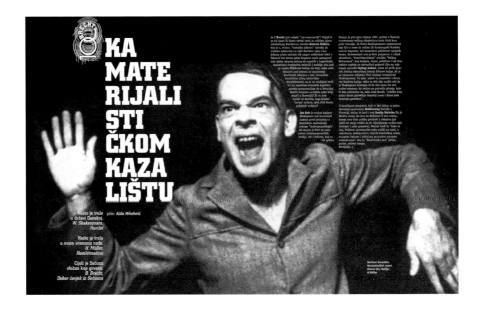

Meta fora
FRAKCIJE

ja vno sti

Tjedan performansa "Javno tijelo"; Zagreb, 14.-18. 10. 1997.

piše: **Suzana Marjanić**
snimio: **Boris Cvjetanović**

Josette Féral manipulaciju kojom performans podvrgava tijelo izvodača (performera) određuje kameleonskim tijelom (1996:208), i iz navedenoga ontologema tijela postavlja dodimost između performansa i teorii: *"Performans je kao fenomen: djelovao kroz tijelo iz sebstva"*, a polazi od istraživa *"tijela koje se ranjava, sakati i rebe (...), tijela koje u potpunosti prihvaća lezionizam"* (1996:209). I dok je, primjerice, **Ron Athey** na Eurokazu *Deliverance*[1] okjario vlastito tijelo "oljuštene" do reti, u kojemu je ispisan tekst života suočavanja s vlastitim Sinom, a u predstavi *Incorruptible Flesh* (**Lawrence Steger & Ron Athey**) tijelo arhaičnom formule hermetičkog "tanonzula" (ženi sličan svetac) - muško zpolovi to tehnikom "klemanja" - provi ing metamorfoziranje je u svjektivu ženskoga zpolovila. pontarijajući u dodirnost body art2 s Incznama ritualne tanatomorfoze i prošličenja: Tjedan performansa pod nazivom Javno tijelo, u organizariji zagrebačkog Sorea centra za zumremenu umjetnost (SCLA-Zagreb) i nezavistnog omjetnečkog projekta *Doma-A cnza-At Home*, koji je odižan u Zagrebu 14.-18. listopada 1997 godine, zvojim radnom naslovom sintagmom ektieni ontiisu je privatno tijelo u *mizaferu javnosti*.

Kameleonsko tijelo i tijelo kao otisak sjećanja (autobiografsko tijelo)

Razgovor s **Tomislavom Gotovcem** prigodom njegova performansa Prilagođavanje objektiva na Trgu maršala Tita i Trg maršala Tito, ostler 24?)

[small column text not fully legible]

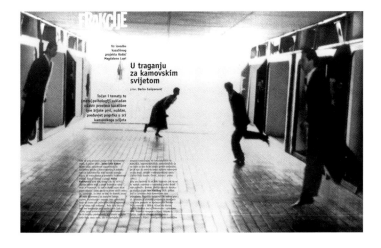

FRAKCIJE

Uz izvedbu kazališnog projekta Redtel Magdalene Lupi

U traganju za kamovskim svijetom

piše: **Darko Gašparović**

Točan i tematu te (meta)psihologiji sukladan odabir prostoka kazalne igre bijaše prvi, možda, preduvjet pogotka u srž kamovskoga svijeta

Ivica Buljan

Bojana Kunst

Of Body Natural and Artificial

★★★Autobiography self-promo booklet

A Day in May Design

CLIENT. Eve Billig
ART DIRECTOR/DESIGNER/ILLUSTRATOR. Eve Billig
TOOLS. QuarkXPress, Illustrator

PAPER. Classic Crest Duplex (cover);
Synergy _ine, Variety (chapters)
PRINTING. Full Circle Press

AUTOBIOGRAPHY
a graphic designer's resumé

EVE BILLIG

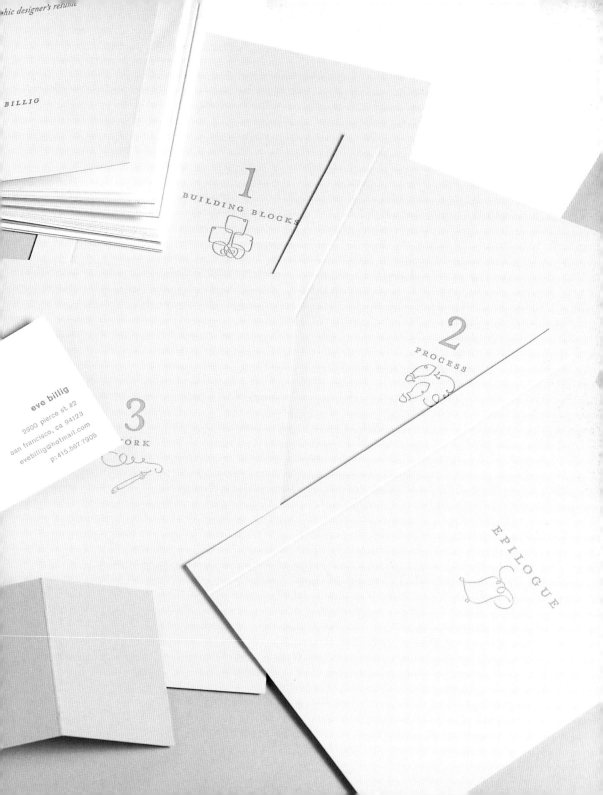

hic designer's resume

BILLIG

1 / BUILDING BLOCKS

2 PROCESS

3 ORK

EPILOGUE

eve billig
2900 pierce st. #2
san francisco, ca 94123
evebillig@hotmail.com
p: 415.567.7905

SCION

CLIENT. Public
ART DIRECTOR. Todd Foreman
DESIGNER. Tessa Lee

TOOLS. Illustrator, Macintosh
PAPER. French Frostone
PRINTING. San Francisco Center for the Book (by Public)

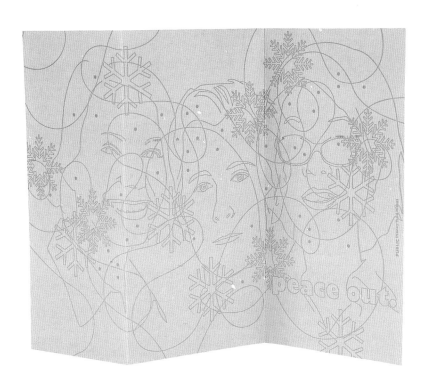

SCION

TOOLS. Illustrator, Macintosh
PAPER. Strathmore
PRINTING. C.J. Graphics

CLIENT. Industry Films
ART DIRECTOR. Vanessa Eckstein
DESIGNER. Stephanie Yung

S60S

IT'S ABOUT A CURE. ON YOUR BEHALF WE MADE A DONATION TO THE AIDS COMMITTEE OF TORONTO AND TO THE BREAST CANCER SOCIETY OF CANADA. HAPPY HOLIDAYS + OUR BEST WISHES FOR 2001. FROM ALL OF US AT INDUSTRY FILMS.

SCION

CLIENT. The Partners Film Company
ART DIRECTOR. Vanessa Eckstein
DESIGNERS. Vanessa Eckstein, Frances Chen

TOOLS. Illustrator, Macintosh
PRINTING. C.J. Graphics

fernando arrioja

BILINGUAL SPANISH

director

michael cerny

director

lisa mann

MUSIC VIDEO BACKGROUND

director

floria sigismondi

MUSIC VIDEO BACKGROUND, STILLS PHOTOGRAPHER
BILINGUAL ITALIAN

director

SCION

CLIENT. Gillespie Design
ART DIRECTOR. Maureen Gillespie

DESIGNER. Liz Schenker
PRINTING. Offset, Lightning Copy

SCION

TOOLS. Illustrator, Photostop, Macintosh
PRINTING. Sheet-fed offset

CLIENT. KO Création
ART DIRECTOR/DESIGNER. Denis Dulude

5095

Biennale internationale de design graphique du Québec • deuxième édition
Quebec's International Graphic Design Biennial • second edition
Internationale graphische **vormgevingsbiennale** Québec • tweede aflevering

INVLOEDS

DENIS DULUDE 19.10.00 9H AM

ZONE::: 18·22

octobre / october / oktober

2000 Montréal Canada Pays-Bas Netherlands Nederland

MERCI À CAPULE ET BERNARD DE M'AVOIR SI GENTIMENT INVITÉ À CETTE DEUXIÈME ÉDITION DE LA BIENNALE. J'EN SUIS TRÈS HONORÉ.
MERCI À PHILIPPE ET MICHEL DE COMPLÈTEMENT LITHO POUR L'IMPRESSION DE CETTE AFFICHE.

SCION

CLIENT. Mo'nia
ART DIRECTOR/DESIGNER/ ILLUSTRATOR. Mo'nia
TOOLS. Photoshop, Freehand, Macintosh

★★★Anni Kuan Design self-promotion

Sagmeister, Inc.

SCION

CLIENT. Anni Kuan Design
ART DIRECTOR. Stefan Sagmeister
DESIGNER/ILLUSTRATOR. Ella Smolarz

TOOLS. Illustrator, Photoshop
PAPER. Newsprint
PRINTING. Newsprint

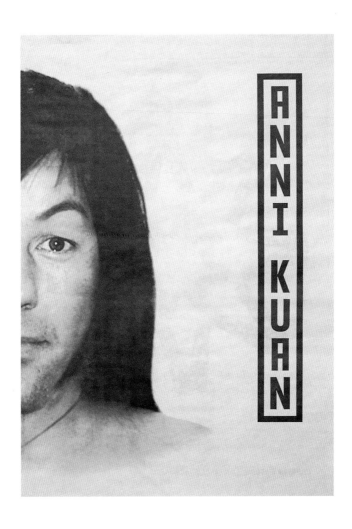

A LINE SKIRT IN COCOA SILK TWEED W/ ULTRA SUEDE TRIM

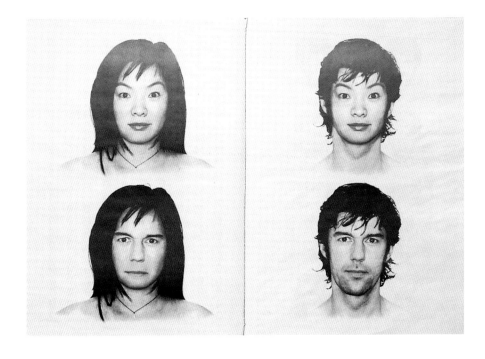

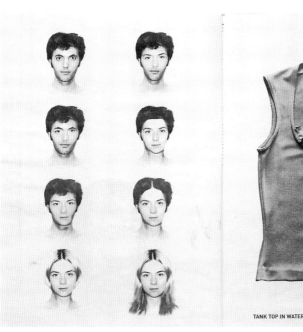

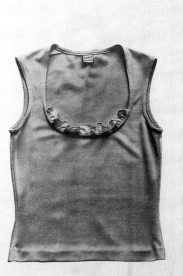

TANK TOP IN WATERMELON MATTE JERSEY WITH CHIFFON RUFFLES

★★★Anni Kuan Design self-promotion

Sagmeister, Inc.

CLIENT. Anni Kuan Design
ART DIRECTOR. Stefan Sagmeister
DESIGNERS. Stefan Sagmeister, Hjalti Karlsson

TOOLS. Illustrator, Photoshop
PAPER. Newsprint
PRINTING. Newsprint

SCION

PHOTOGRAPH OF
NEW YORK CITY
SKYLINE REFLECTED
IN RAIN PUDDLE.

PHOTOGRAPH OF
ANNI KUAN
EMBROIDERED LABEL,
THREADS SHOWING.

SUPER SHARP PHOTOGRAPH OF LUMPS OF BLACK COAL, ARRANGED TO TAKE THE SAME OUTLINE SHAPE AS DARK HAIRED MODEL ON OPPOSITE PAGE.

PHOTOGRAPH OF DARK HAIRED MODEL (WITH LIGHT MUSTACHE) IN ANNI KUAN BLACK RAYON MATTE JERSEY FLOOR-LENGTH DRESS WITH A LOW V-NECK FRONT AND BELL SLEEVES WITH BLACK FUR TRIM.

PHOTOGRAPH OF RED STRING, LYING LOOSELY AND RESEMBLING BORED BLOND WOMAN.

PHOTOGRAPH OF BORED BLOND WOMAN, ONE BREAST SHOWING, CARRYING NAKED BABY, IN A LIPSTICK RED FUZZY ANGORA LOW-CUT BALLERINA TOP OVER A MULTI-COLORED COLLAGED SILK CHARMEUSE BIAS-CUT LONG SKIRT.

PHOTO OF RECLINING RED HAIRED GIRL WEARING LARGE SQUARE SUNGLASSES AND LICKING CHERRY LOLLIPOP IN BLOOD ORANGE DOUBLEKNIT TEE WITH MOHAIR CORD TRIM WORN OVER BROWN STRETCH WOOL CROPPED PANTS WITH SHAGGY CHENILLE CUFFS, ACCESSORIZED WITH A BERRY MOHAIR TOTE BAG.

PHOTOGRAPHIC IMAGE OF 3 BRICKS GROUPED TO RESEMBLE CONTOUR OF RED HAIRED GIRL.

★★★Al Fitr holiday greeting

Nassar Design

CLIENT. Harvard School of Government
ART DIRECTOR/DESIGNER. Nelida Nassar

TOOLS. QuarkXPress, Photoshop
PAPER. Champion Benefit 100#C
PRINTING. Offset

SCION

TOOLS. Photoshop, QuarkXPress, Macintosh, photocopy
PAPER. Black Uncoated Recycled Stock
PRINTING. Offset

CLIENT. Seth Affoumado
ART DIRECTOR/DESIGNER. Tom Sieu

S095

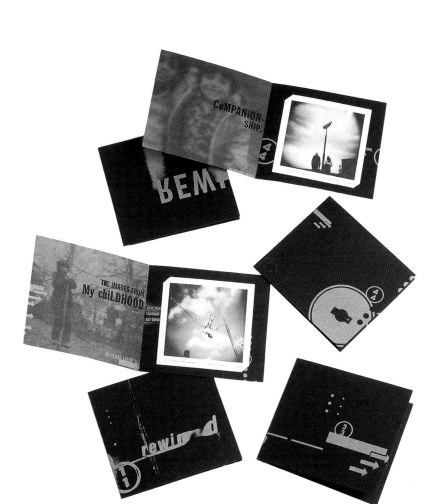

MACRO

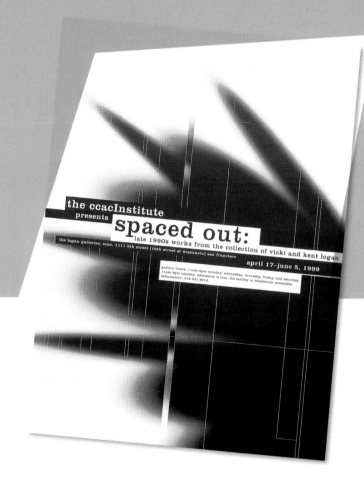

the ccacInstitute
presents

spaced out:
late 1990s works from the collection of vicki and kent logan

the logan galleries, ccac, 1111 8th street [16th street at wisconsin] san francisco

april 17–june 5, 1999

gallery hours: 11am–5pm monday, wednesday, thursday, friday, and saturday.
11am–8pm tuesday. admission is free. the facility is wheelchair accessible.
information: 415.551.9210.

Details at a Distance

posters / installations

CLIENT. California College of Arts & Crafts
ART DIRECTOR. Jennifer Morla

DESIGNERS. Sara Schneider, Jennifer Morla
TOOLS. QuarkXPress, Illustrator, Photoshop, Macintosh

PAPER. Newsprint
PRINTING. Offset, black ink

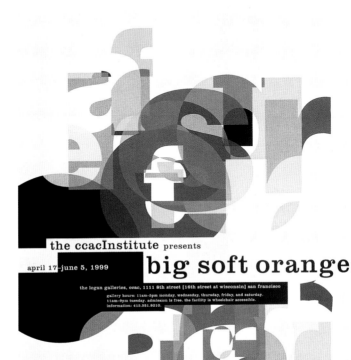

the ccacInstitute presents

april 17-june 5, 1999 big soft orange

the logan galleries, ccac, 1111 8th street [16th street at wisconsin] san francisco

gallery hours: 11am-5pm monday, wednesday, thursday, friday, and saturday.
11am-9pm tuesday. admission is free. the facility is wheelchair accessible.
information: 415.551.9210.

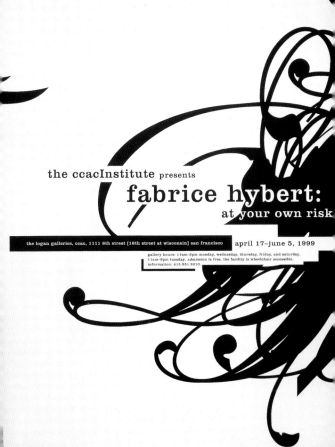

the ccacInstitute presents

fabrice hybert:
at your own risk

the logan galleries, ccac, 1111 8th street [16th street at wisconsin] san francisco april 17–june 5, 1999

gallery hours: 11am–5pm monday, wednesday, thursday, friday, and saturday.
11am–9pm tuesday. admission is free. the facility is wheelchair accessible.
information: 415.551.9210.

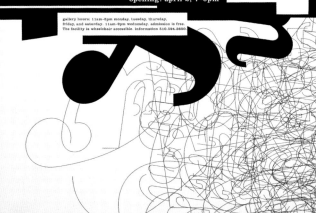

the ccacInstitute presents kara walker

capp street project:

oliver art center, oakland campus, 5212 broadway

opening: april 2, 7–9pm

april 3–may 15, 1999

gallery hours: 11am–5pm monday, tuesday, thursday,
friday, and saturday. 11am–9pm wednesday. admission is free.
The facility is wheelchair accessible. information 510.594.3650.

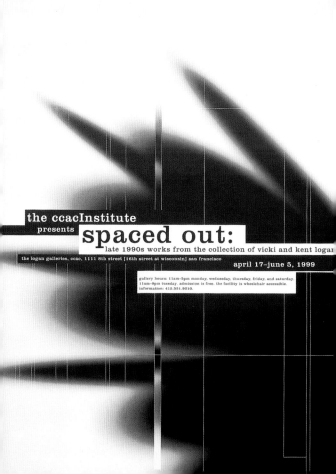

the ccacInstitute

presents

spaced out:

late 1990s works from the collection of vicki and kent logan

the logan galleries, ccac, 1111 8th street [16th street at wisconsin] san francisco

april 17–june 5, 1999

gallery hours: 11am–5pm monday, wednesday, thursday, friday, and saturday.
11am–9pm tuesday. admission is free. the facility is wheelchair accessible.
information: 415.551.9210.

***Exhibition poster
Friedhelm Plassmeier

CLIENT. Society for Christian and Jewish Partnership
DESIGNER. Friedhelm Plassmeier

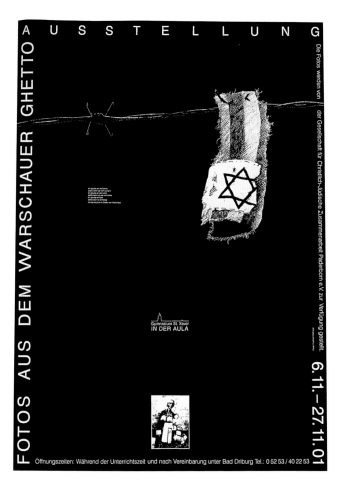

★★★Prairie Sun poster

Tom & John: A Design Collaborative

PAPER. Uncoated Industrial Recycled
PRINTING. Diazo

CLIENT. Prairie Sun Recording Studios
ART DIRECTOR/DESIGNER. Tom Sieu
TOOLS. Photoshop, QuarkXPress, Macintosh

★★★Love Square & Circle

Studio International

CLIENT. Museum Documentation Croatia
ART DIRECTOR/DESIGNER/ILLUSTRATOR.
Boris Ljubičić

TOOLS. Corel, PC
PAPER. Kunstdruck 250g
PRINTING. Silkscreen

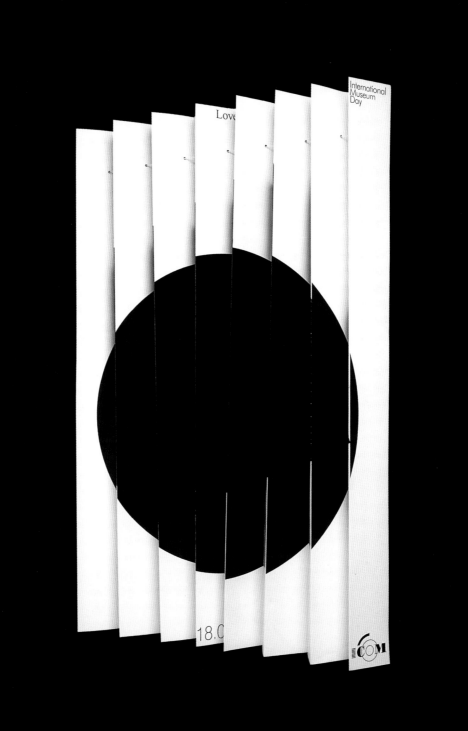

MACRO

Lure Design, Inc.

★★★"Art" poster

CLIENT. Orlando–UCF Shakespeare Festival
DESIGNERS. Paul Mastriani; Jeff Matz

TOOLS. Illustrator, Photoshop
PAPER. Mohawk textures, Ultrafelt
PRINTING. Offset with embossing

Orlando–UCF Shakespeare Festival
Tickets $16 and $20
ART
Box (407) 893-4600
Office / Loch Haven Park
Lowndes Shakespeare Center
a new play by Yasmina Reza (Translated by Christopher Hampton)
Jan.12
through
Feb.11
2001

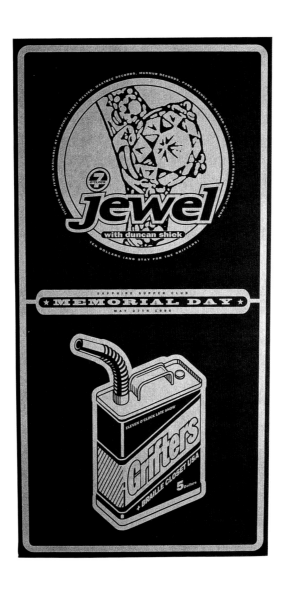

★★★Jewel/Grifters poster

Lure Design, Inc.

CLIENT. Figurehead Records
DESIGNER/ILLUSTRATOR. Jeff Matz

TOOLS. Illustrator, Photoshop
PAPER. French Speckletone
PRINTING. Offset, silver ink

MACRO

Lure Design, Inc.

★★★ "Woman in Black" posters

CLIENT. Orlando–UCF Shakespeare Festival
DESIGNERS. Paul Mastriani, Jeff Matz
TOOLS. Illustrator, Photoshop

PAPER. Fraser Pegasus Midnight Black Vellum
PRINTING. Offset, silver ink

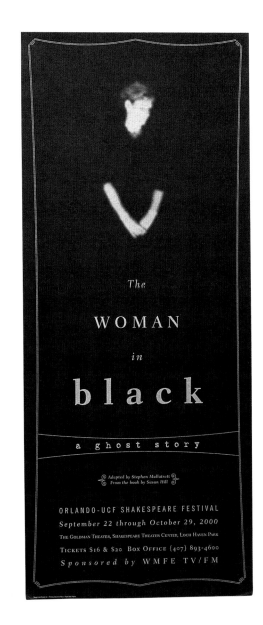

The

WOMAN

in

black

a ghost story

Adapted by Stephen Mallatratt
From the book by Susan Hill

ORLANDO-UCF SHAKESPEARE FESTIVAL
September 22 through October 29, 2000

THE GOLDMAN THEATER, SHAKESPEARE THEATER CENTER, LOCH HAVEN PARK

TICKETS $16 & $20 BOX OFFICE {407} 893-4600

Sponsored by WMFE TV/FM

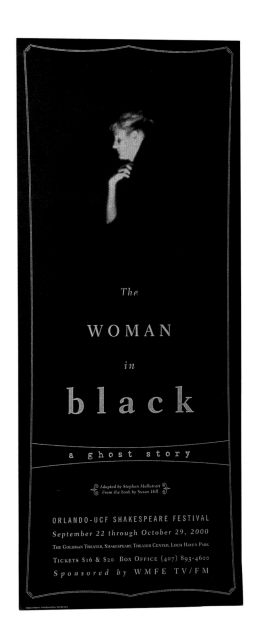

***"How Do You Know What You Know?" posters

Cabra Diseño

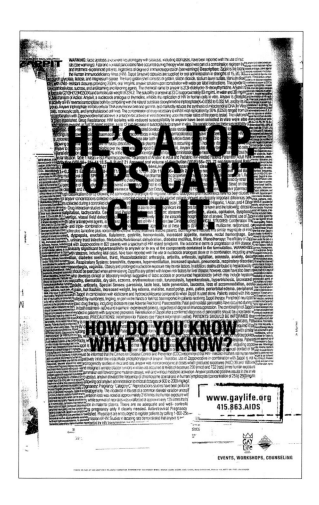

CLIENT. San Francisco AIDS Foundation
ART DIRECTOR. Raul Cabra
DESIGNERS. Mark Santa Ana, Wesley Ito, Betty Ho
PHOTOGRAPHER. Ken Probst
TOOLS. QuarkXPress, Macintosh
PAPER. Cougar Untreated 86#C
PRINTING. Gateway Graphics

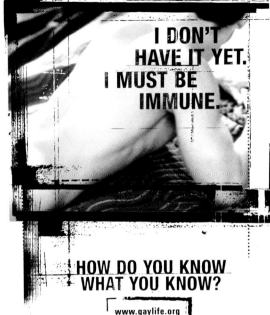

I DON'T HAVE IT YET. I MUST BE IMMUNE.

HOW DO YOU KNOW WHAT YOU KNOW?

www.gaylife.org
415.863.AIDS

GAY Life

EVENTS, WORKSHOPS, COUNSELING

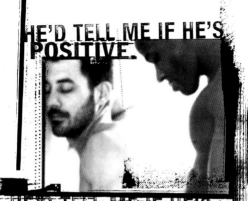

HE'D TELL ME IF HE'S
POSITIVE.

HE'D TELL ME IF HE'S
NEGATIVE.

HOW DO YOU KNOW
WHAT YOU KNOW?

www.gaylife.org
415.863.AIDS

EVENTS, WORKSHOPS, COUNSELING

★★★Archers of Loaf poster

Lure Design, Inc.

CLIENT. Figurehead Records
DESIGNER/ILLUSTRATOR. Jeff Matz

TOOLS. Illustrator, Photoshop
PAPER. Chipboard
PRINTING. Silkscreen

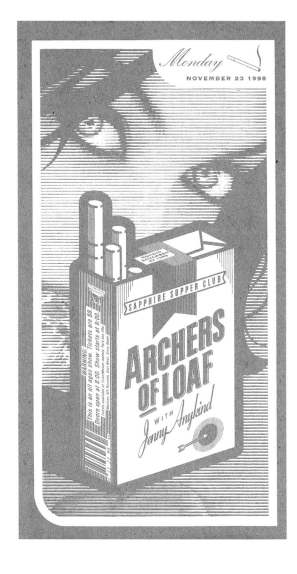

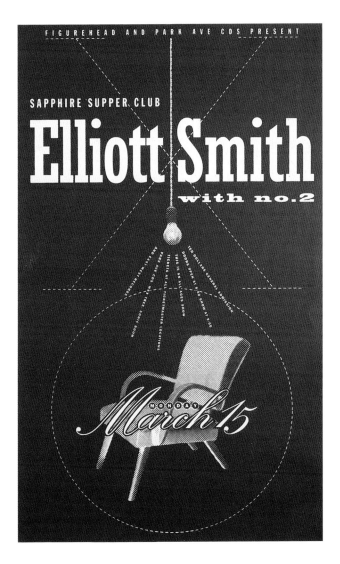

***Elliott Smith poster
Lure Design, Inc.

CLIENT. Figurehead Records PAPER. Confetti
DESIGNER. Jeff Matz PRINTING. Silkscreen
TOOLS. Illustrator, Photoshop

***Multimedia Institute MIZ

Arkzin d.o.o.

CLIENT: Multimedia Institute Miz, Zagreb, Croatia
ART DIRECTOR: Dejan Dragosavac-Rutta

DESIGNERS: Dejan Dragosavac, Dejan Kršić
TOOLS: Freeland, Photoshop
PRINTING: Offset

MACRO

★★★ 2000 MFA Exhibit poster
University of Washington

H E N R Y A R T G A L L E R Y

THE HENRY is located at 15th Avenue NE and NE 41st Street. Tuesday, Wednesday, Friday; Saturday, Sunday from 11-5 and Thursday 11-8. 206-543-2280 www.henryart.org for more information.

2000

F

(master of the fine arts)

. M A

: EXHIBIT

university of washington
school of art

reception Friday May 26 5:00-8:00pm

MAY 27 - JUNE 25

TOOLS. Illustrator, Macintosh
PAPER. Lustro Archival Dull 100 #T
PRINTING. Olympus Press

CLIENT. University of Washington
School of Art
DESIGNER. Karen Cheng

MACRO

***Rathaus poster

Niklaus Troxler Design

CLIENT. Rathaus
ART DIRECTOR/DESIGNER. Niklaus Troxler
PRINTING. Silkscreen

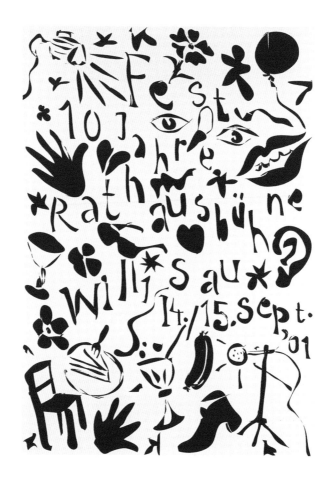

MACRO

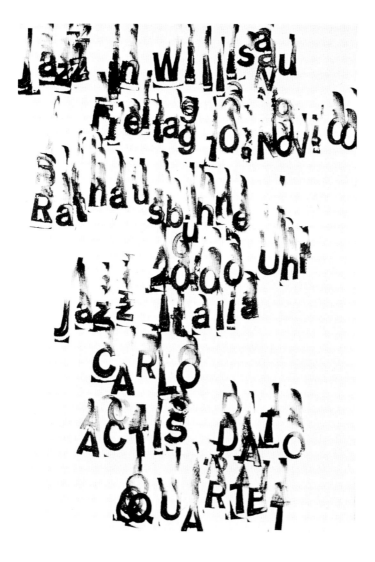

CLIENT. Jazz in Willisau
ART DIRECTOR/DESIGNER. Niklaus Troxler

PAPER. Poster, 90.5 x 128 cm
PRINTING. Silkscreen

MACRO

***Jazz in Willisau poster

Niklaus Troxler Design

CLIENT. Jazz in Willisau

ART DIRECTOR/DESIGNER. Niklaus Troxler

PAPER. Poster, 90.5 x 128 cm

PRINTING. Silkscreen

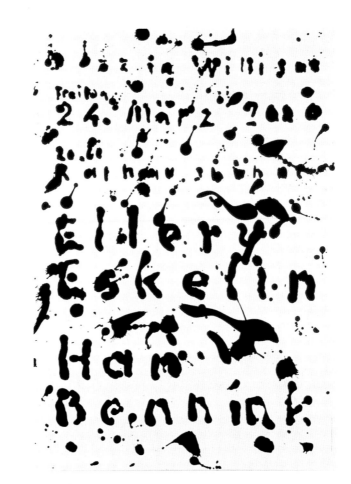

★★★ArtHip! Masquerade Ball poster
Shoehorn Design

ILLUSTRATOR. Will Hornaday
TOOLS. Illustrator, Macintosh
PAPER. Quantum Opaque White 80#C
PRINTING. The Whitley Company

CLIENT. Austin Museum of Art
ART DIRECTOR. Will Hornaday
DESIGNERS. Ted Roddy, Will Hornaday

MACRO

★★★October 18 lecture poster

Jennifer Sterling Design

CLIENT. California College of Arts and Crafts
ART DIRECTOR/DESIGNER. Jennifer Sterling
TOOLS. Illustrator, Photoshop, Macintosh

MATERIALS. Lexan
PRINTER. Bel Aire Display

sPE

symposium

MACRO

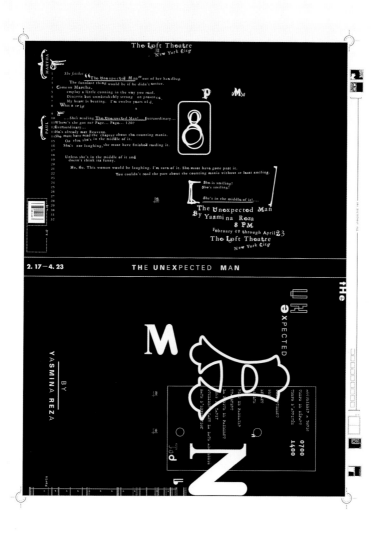

★★★Unexpected Man poster
Jennifer Sterling Design

CLIENT. *Critique* magazine
ART DIRECTOR/DESIGNER. Jennifer Sterling

TOOLS. Illustrator, Macintosh
PAPER. Arches Watercolor
PRINTING. Trillium



MACRO

***Portlite poster

Red Alert Visuals

CLIENT. Portlite
ART DIRECTOR/DESIGNER. Jason Rosenberg
TOOLS. QuarkXPress, Photoshop, Streamline

PAPER. 60# Gloss
PRINTING. Hand-screened

***Café du Nord poster

Red Alert Visuals

TOOLS. QuarkXPress, Photoshop, Streamline
PAPER. 60# Coated
PRINTING. Hand-screened

CLIENT. Café du Nord
ART DIRECTOR/DESIGNER. Jason Rosenberg

WHEN KBOO RADIO SHOVES THE GRATEFUL DEAD DOWN YOUR THROAT, THE EVIL WEED IS SURE TO FOLLOW.

At KBOO [90.7 FM] the psychopharmacological hell-hole that was the 60s never ended. It lives on in the form of "THE GRATEFUL DEAD HOUR," a mind-numbing collection of "BOOGIE JAMS." If the entire nation followed the pied-piper call of these hacky-sack hooligans, where would we be? Stuck on a collective farm answering "YES, COMRADE" to our Communist enslavers. It's time for these FREE-LOVE freaks to put down their pipes, shave their DREADLOCKS, enlist in the Army and become God-fearing Americans. Unplug KBOO [90.7 FM] before the stench of pot smoke makes us all coke-headed ZOMBIES.

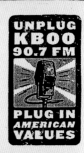

UNPLUG KBOO 90.7 FM

PLUG IN AMERICAN VALUES

CONVINCED? VOTE BELOW!

SEND $5 FOR YOUR BUMPER STICKER.

☐

YES!
*Unplug KBOO
before it's
TOO LATE!*

Name: _____

Address: _____ City: _____ State: ___ Zip: _____

Send To: UNPLUG KBOO, 408 SW 2nd Ave. Suite 411, Portland, Oregon 97204

☐

NO!
*Don't unplug KBOO.
Jerry's not dead, he just
SMELLS FUNNY.*

MACRO

MATTER

★★★"No Matter" poster

CLIENT. MATTER
ART DIRECTOR. Jason C. Otero

DESIGNERS. Jason C. Otero, Rick Griffith,
Joe Lamarre, Shennon Murray,
Paco Proano

TOOLS. Imagination, Bare Hands
PAPER. Various
PRINTING. Screenprinting

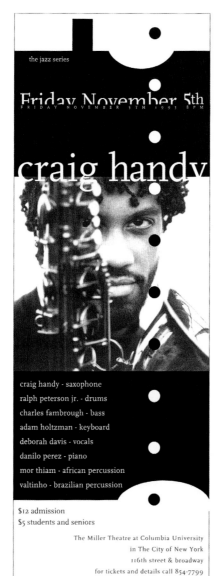

the jazz series

Friday November 5th
FRIDAY NOVEMBER 5TH 1993 8PM

craig handy

craig handy - saxophone
ralph peterson jr. - drums
charles fambrough - bass
adam holtzman - keyboard
deborah davis - vocals
danilo perez - piano
mor thiam - african percussion
valtinho - brazilian percussion

$12 admission
$5 students and seniors

The Miller Theatre at Columbia University
in The City of New York
116th street & broadway
for tickets and details call 854-7799

★★★The Jazz Series: Craig Handy poster

CLIENT. Miller Theater
ART DIRECTOR/DESIGNER. Rick Griffith
TOOLS. QuarkXPress, Macintosh
PAPER/PRINTING. Brownline

***Innerschweizer Filmtage poster

Mix Pictures Grafik

CLIENT. Kleintheater Luzern
ART DIRECTOR/DESIGNER.
Erich Brechbühl

TOOLS. Freehand, Macintosh
PAPER. Poster
PRINTING. Silkscreen

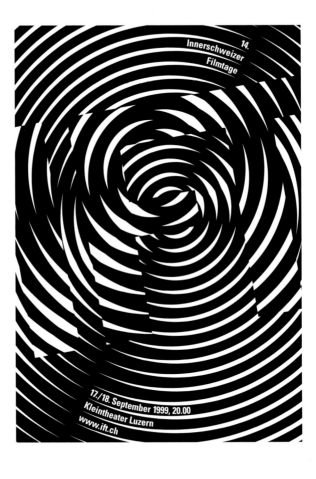

Jugendtheater Sempach spielt
frei nach Charles de Coster
in der Zehntenscheune Sempach
am 13./15./16./20./22./23. Juni, jeweils 20 Uhr
Vorverkauf: Gärtnerei Gabriel 041-460 17 44
www.mixpictures.ch/jugendtheater

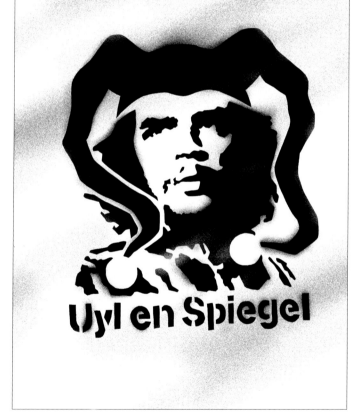

Uyl en Spiegel

★★★Jugendtheater Sempach poster

Mix Pictures Grafik

TOOLS. Photoshop, Macintosh
PAPER. Poster
PRINTING. Silkscreen

CLIENT. Jugendtheater Sempach
ART DIRECTOR/DESIGNER. Erich Brechbühl

MICRO

An Intimate Impression

invitations / announcements

CLIENTS. Ellen Bruni-Gillies & Dan Gillies
ART DIRECTOR/DESIGNER. Ellen Bruni-Gillies
ILLUSTRATOR. Ward Shumacher

TOOLS. QuarkXPress, Photoshop, Macintosh
PAPER. Fox River Teton Tiara White
PRINTING. Full Circle Press

★★★Milo birth announcement

Ellen Bruni-Gillies Design

Tony, Nicolas & Melinda Maniscalco
celebrate the *miraculous* arrival of

Luca Isabella Maniscalco

born JUNE 18, 2001 — *weighing* 9 LBS., 3 OZS.
AND *measuring* 21½ INCHES LONG.
WILL WONDERS *never* CEASE?

MANISCALCO
1010 D STREET
PETALUMA
CA 94952

TONY AND MELINDA MANISCALCO CELEBRATE
THE ARRIVAL OF

NICOLAS PATRICK MANISCALCO

born JUNE 30, 1997 — *weighing* 7 LBS., 3 1/2 OZS.
AND *measuring* 22 INCHES LONG.

LIFE WILL *never* BE THE SAME.

CLIENTS. Melinda and Tony Maniscalco
ART DIRECTORS/DESIGNERS. Melinda and
Tony Maniscalco
ILLUSTRATOR. Clip art
TOOLS. Illustrator, Macintosh
PRINTING. Full Circle Press

★★★Nicolas and Luca birth announcements

Homespun Design

The holiday season this year is different from those in the past.

Our views and feelings about our lives and our
work are that much more present. In these times,
we at Torani are especially grateful to have so
many wonderful relationships with you—our
customers, our partners, our friends. We send
along heartfelt wishes for a warm and happy
holiday season.

Your friends at Torani

A donation has been made in honor of Torani's
distributors, customers and partners

to assist in the relief efforts of the greatest...
The American Red Cross, Relief Fund
Windows of Hope Family Relief Fund
New York Times 911 Neediest Fund

and to support the hope of the future...
Youth Spiritski Clubs
Boys and Girls Clubs

Torani

233 East Harris Avenue, South San Francisco, CA 94080

CLIENT. Torani
ART DIRECTOR/ILLUSTRATOR.
Laura Bauer

DESIGNER. Gary Wong
TOOLS. Illustrator, Macintosh
PRINTING. Full Circle Press

★★★Torani holiday card

Anvil Graphic Design

CLIENT. Miro Senica
ART DIRECTOR/DESIGNER. Edi Berk
TOOLS. Illustrator, Macintosh
PAPER. Conqueror Vergata
PRINTING. Offset

★★★Anno Aetatis Suae 40 invitation

KROG

MICRO

The VENTURA COUNTY STAR and the
VENTURA COUNTY MEDICAL RESOURCE FOUNDATION
present the

NINTH ANNUAL
DAVID C. FAINER M.D.
AWARDS DINNER

PROGRAM RECORD

CLINIC OFFICE: <u>SPANISH HILLS GOLF & COUNTRY CLUB</u>

THIS RECORD MAY BE REMOVED FROM THE SITE

Feel free to remove this record from designated area
without notifying Medical Records

<u>INFORMATION IN THIS RECORD IS NOT CONFIDENTIAL</u>

PATIENT'S NAME

LAST

FIRST

MIDDLE

2005	2004	2003	2002	2001	2000	1999	1998	1997	1996	1995	1994	1993

★★★Fainer Awards Dinner invite and program

Barbara Brown Marketing & Design

PRESCRIPTION

Name: NINTH ANNUAL DAVID C. PAINER M.D. AWARDS DINNER

Date: NOVEMBER 2, 2001

Place: SPANISH HILLS GOLF & COUNTRY CLUB

Attire: BLACK TIE OPTIONAL

Evening Festivities
Sig: Silent Auction & No-Host Bar 6:15 pm
 Dinner / Program 7:45 pm

Disp: One Fun Evening!

Instructions: Register early for best bed assignment

John Keats, M.D.
Master of Ceremonies

vcp

Refill: Annually

PLACE
STAMP

VENTURA COUNTY
MEDICAL RESOURCE FOUNDATION
250 Citrus Grove Lane Suite 240
Oxnard, California 93030

ADDRESS SERVICE REQUESTED

Ninth Annual David C. Painer M.D. Awards Dinner

HISTORY and PHYSICAL

Please fill out and take a seat. The Doctor will be with you shortly.

Name:		State:	Zip:
Address:			
City:			
Telephone:			

[] I/We want to be a **Gold Sponsor** (or $2,500* with VIP seating for 12.
 (includes 1/4 page ad in program, recognition as Gold sponsor in publicity materials and at dinner)
[] I/We want to be a **Silver Sponsor** for $1,500* with VIP seating for 4.
 (includes 1/8 page ad in program, recognition as Silver sponsor in publicity materials and at dinner)
[] I/We want to be a **Bronze Sponsor** for $900* with VIP seating for 2.
[] I/We would like to reserve _____ tables(s) of 12 at $1,800 ($900 tax-deductible*)
[] I/We would like to reserve _____ seat(s) at $150 per person ($75 tax-deductible)
[] I/We are unable to attend. Please accept $ _____ as a tax-deductible contribution.

Total $ _____ []Check Enclosed. Please make check to: VCMRF
 []Master Card []Visa

Card Number: _____ Expir. Date: _____
Card Member Name: _____
Signature: _____ . Please Mail or FAX to (805) 485-0416

Please RSVP by October 23, 2001. Reservations will be held at the door.
Questions call (805) 485-8050.

I've schedu...
appoint...
DIAGNOSIS:

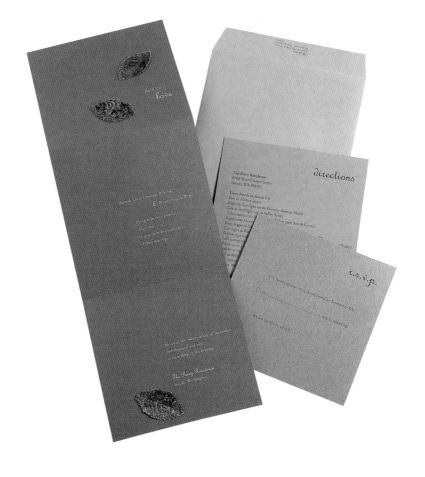

CLIENTS: Hannah Roberts, Bryan Wygal
ART DIRECTOR: Hannah Wygal
DESIGNERS: Hannah Wygal, Theresa Veranth

TOOLS: Freehand
PAPER: French Construction
PRINTING: The Press

★★★Roberts & Wygal wedding invitation

Monster Design

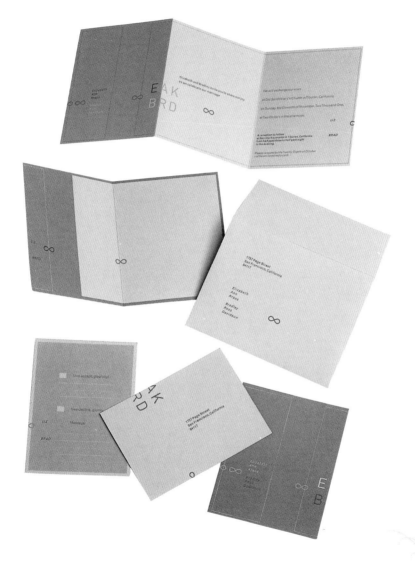

CLIENTS. Brad Davidson, Liz Kraus
ART DIRECTOR. Todd Foreman
DESIGNER. Tessa Lee

TOOLS. Illustrator, Macintosh
PAPER. French Frostone
PRINTING. Quad Express

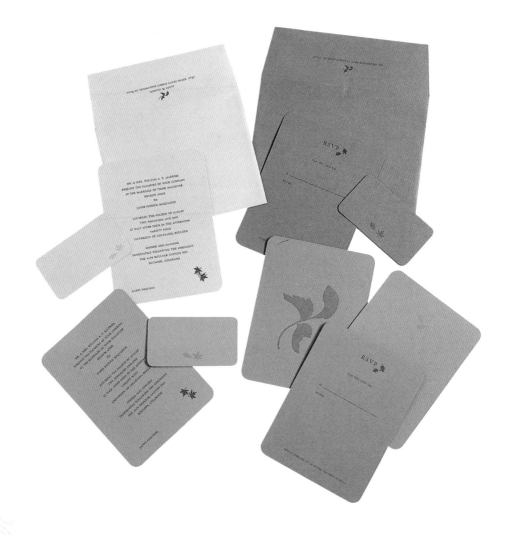

CLIENTS. Sharon Allpress, James McQuarrie

ART DIRECTORS/DESIGNERS.
Lesley Hathaway, Eve Billig

TOOLS. QuarkXPress, Illustrator
PAPER. French Construction
PRINTING. Full Circle Press

★★★"The Dahlia" wedding invitation

A Day in May Design

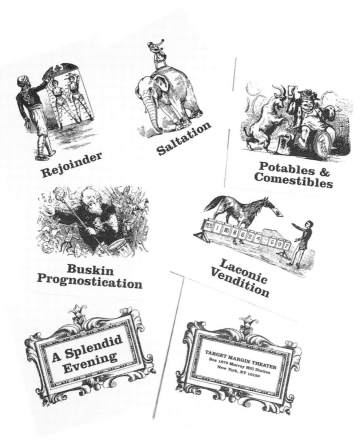

Rejoinder

Saltation

Potables &
Comestibles

Buskin
Prognostication

Laconic
Vendition

A Splendid
Evening

TARGET MARGIN THEATER
Box 1879 Murray Hill Station
New York, NY 10156

CLIENT. Target Margin Theater
ART DIRECTOR/DESIGNER.
Noah Scalin

TOOLS. QuarkXPress, Macintosh
PRINTING. Offset

★★★"A Splendid Evening" invitation
ALR Design

CLIENT. Nassar Design
ART DIRECTOR/DESIGNER. Nelida Nassar

TOOLS. QuarkXPress, Illustrator
PAPER. Cromatica
PRINTING. Silkscreen

★★★New Millenium greeting

Nassar Design

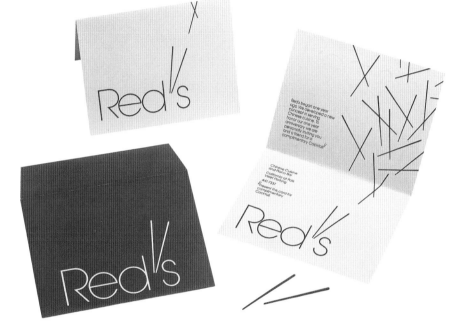

CLIENT. Red's Restaurant—Chinese Cuisine & Piano Bar TOOLS. QuarkXPress, Illustrator
ART DIRECTOR/DESIGNER/ILLUSTRATOR. Warren Welter PRINTING. Technigraphics

★★★Red's One-Year Anniversary invitation
Second Floor

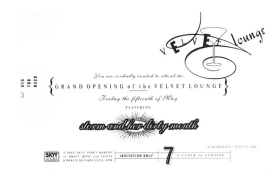

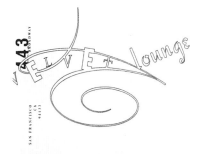

CLIENT. Velvet Lounge
ART DIRECTOR. Steve Barretto
TOOLS. Illustrator, Macintosh

PAPER. Somerset Textured Softwhite
250g/m²
PRINTING. Classic Letterpress

MICRO

132

★★★Velvet Lounge Grand Opening invitation

Flux

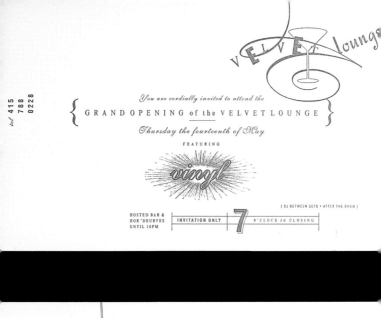

You are cordially invited to attend the

{ GRAND OPENING of the VELVET LOUNGE }

Thursday the fourteenth of May

FEATURING

vinyl

(DJ BETWEEN SETS • AFTER THE SHOW)

HOSTED BAR &
HOR'DEURVES
UNTIL 10PM

| INVITATION ONLY | **7** | 8'CLOCK to CLOSING |

tel 415
788
0228

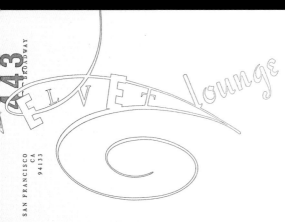

143
BROADWAY

SAN FRANCISCO
CA
94133

CLIENT. Kitchen K—A Design Gallery
ART DIRECTORS. Jeff Fabian, Sam Shelton

DESIGNERS. Beth Clawson, Mike Joosse,
Jenny Harrington, Scott Rier, Kate Kroener,
Natalie Politis, Jackie Ratsch, Beverly Hunter

TOOLS. QuarkXPress, Macintosh
PAPER. Cardboard
PRINTING. Triangle looseleaf

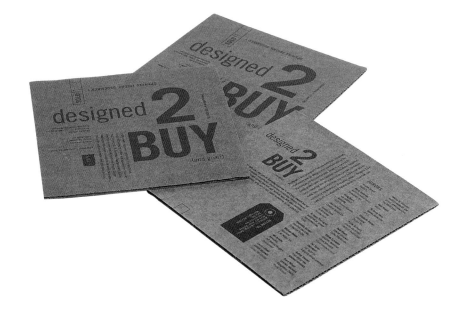

★★★Designed 2 Buy announcement

Kinetik Communication Graphics

CLIENT. Kitchen K—A Design Gallery
ART DIRECTORS. Jeff Fabian, Sam Shelton

DESIGNERS. Beth Clawson, Mike Joosse,
Jenny Harrington, Scott Rier, Kate Kroener,
Natalie Politis, Jackie Ratsch, Beverly Hunter

TOOLS. QuarkXPress, Macintosh
PAPER. Potlatch McCoy
PRINTING. Select Printing

★★★(50x3) Exhibition announcement
Kinetik Communication Graphics

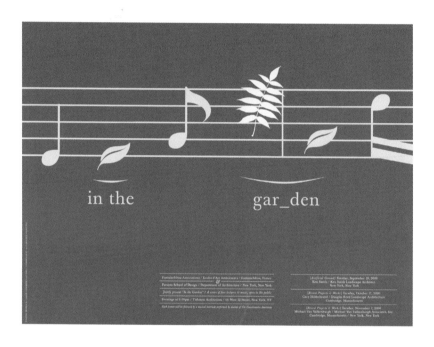

CLIENT. Fontainebleau Associations
ART DIRECTOR. Michael Graziolo
DESIGNER. Eiji Tsuda

TOOLS. Illustrator, Macintosh
PAPER. Finch Opaque

★★★Fountainebleau poster

Drive Communications

PAPER. 50# White Husky Offset (invite), 80# White Exact Vellum Bristol (reply card), Sundance Felt (A2 and A6 eps)
PRINTING. Norco Printing

CLIENT. Headlands Center for the Arts
ART DIRECTOR. Jennifer Jerde
DESIGNER. Holly Holmquist

★★★Mystery Ball 2000 invitation

Elixir Design

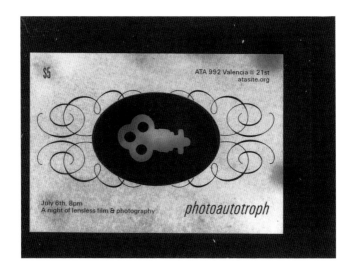

CLIENT. Artists' Television Access (ATA)
ART DIRECTOR. Aaron Cruse
DESIGNERS. Aaron Cruse, Austin Lee, Alexis Bravos

TOOL. Copy camera
MATERIALS. Clip art, small objects, chemistry, sun
PRINTING. Cyanotype (blueprint)

★★★ Photoautotroph invitation

Dead Letter Type

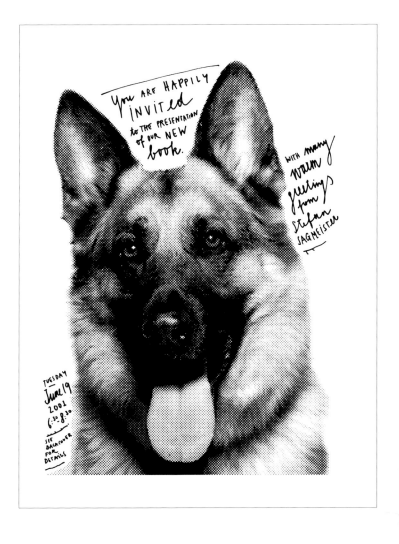

TOOLS. Illustrator, Photoshop
PAPER. Newsprint
PRINTING. Newsprint

CLIENT. Stefan Sagmeister
ART DIRECTOR/DESIGNER/
ILLUSTRATOR. Stefan Sagmeister

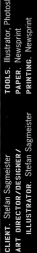

***Sagmeister, Inc. Book Presentation invitation
Sagmeister, Inc.

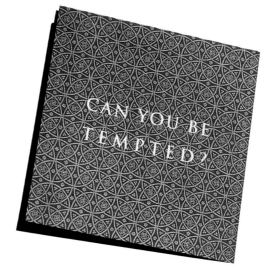

CAN YOU BE
TEMPTED?

CLIENT. Studio Yu
DESIGNER. Jeff Matz

TOOLS. Photoshop, QuarkXPress
PRINTING. Offset, silver ink

MICRO

140

★★★Eden invitation

Lure Design, Inc.

PLEASE JOIN US FOR A NIGHT OF DARING TEMPTATIONS ON SATURDAY, OCTOBER 28TH 2000 AT THE SAPPHIRE. PLEASE BE DRESSED TO KILL IN YOUR FAVORITE COSTUME – BE IT FETISH OR FANTASY– AND PRESENT OUR ENCLOSED SIGNATURE FLOGGER FOR ENTRY TO THIS EXCLUSIVE EVENING OF DELIGHT. ENTICING ENTERTAINMENT SHALL BE PROVIDED BY

A HOST OF HEAVENLY SEDUCE YOUR SENSES. WILL BE SERVED TO PALATE AND REMOVE FANTASIES BEGIN 11:15 PM. $25 IS

Eden

CREATURES TO SINFUL INFUSIONS TANTALIZE YOUR YOUR INHIBITIONS. REALIZATION AT REQUESTED PER

GUEST TO ATTEND THIS EXTREMELY PRIVATE EVENT WITH LIMITED SPACE AVAILABLE. PLEASE CALL 407 592 6949 BY OCTOBER 21ST TO CONFIRM YOUR EXPERIENCE IN THE GARDEN OF EDEN AND TO RECEIVE FURTHER INSTRUCTIONS FOR ENTRY.

FROM THE EXOTIC TO THE EROTIC

VOLUME

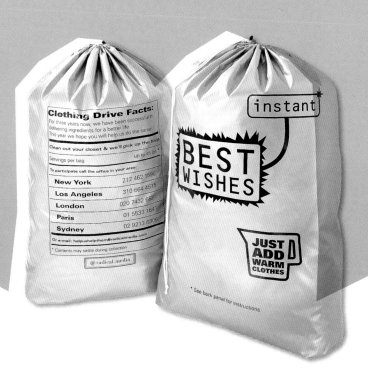

The Third Dimension

packaging / promotions / books / CDs / menus / doorstop

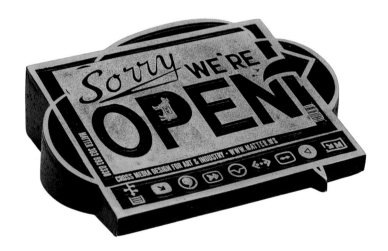

★★★"Sorry We're Open" doorstop

MATTER

CLIENT. MATTER
ART DIRECTORS. Rick Griffith,
Jason C. Otero
DESIGNER. Rick Griffith

TOOLS. Illustrator, Macintosh
MATERIALS. Poured plastic, resin, sand
FABRICATOR. James Stoltzenbach

HONG KONG DEFINING THE EDGE

ESSAYS AND STUDENT PROJECTS · HARVARD DESIGN SCHOOL · ARTICLE CONTRIBUTORS

HONG KONG DESIGN SCHOOL

PETER ROWE · SASKIA SASSEN · NICHOLAS BROOKE · CHRISTINE LOH · MICHAEL SORKIN

HONG KONG DEFINING THE EDGE

ELIZABETH MOSSOP · RICHARD MARSHALL · JOE BROWN

CLIENT. Harvard University
Design School
ART DIRECTOR/DESIGNER.
Nelida Nassar

TOOL. QuarkXPress
PAPER. Lenticular Film Mounted
in Card Stock
PRINTING. Silkscreen

★★★Hong Kong Defining the Edge
Nassar Design

UNPACKED
THE PAINT IS DRY AND THE CONTRACTOR HAS TURNED IN HIS KEY.
IT'S TIME TO SHOW OFF OUR RENOVATED STUDIO AND MINGLE WITH
FRIENDS OLD AND NEW.

JOIN US @ PYLON
THURSDAY 29 NOVEMBER 445 ADELAIDE ST. W. AFTER 5PM
PLENTY OF FREE CARDBOARD
RSVP ROBIN 416/504 4331 BY 19 NOVEMBER

★★★Pylon party invite
Pylon Design, Inc.

CLIENT. Pylon Design, Inc.
ART DIRECTORS. Scott Christie, Kevin Hoch
DESIGNER. Erin Boyce

TOOLS. QuarkXPress, Macintosh
MATERIALS. Black ink, rubber stamp
PRINTING. Rite Rubber Stamp Company

Reserved Parking for
the Last-Minute Christmas
Shopper

CLIENT. Pylon Design, Inc.
ART DIRECTORS. Scott Christie, Kevin Hoch
DESIGNER. Scott Christie

TOOLS. QuarkXPress, Macintosh
PAPER. Avery Label
PRINTING. Laser printer

★★★Christmas promo
Pylon Design, Inc.

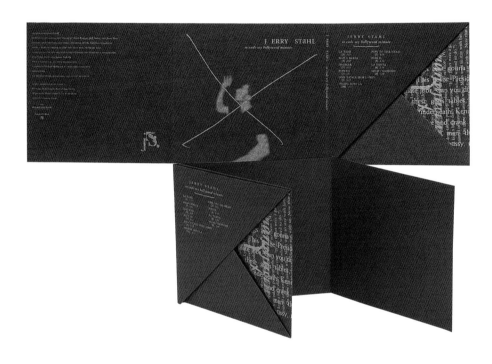

★★★Jerry Stahl CD jacket
Lure Design, Inc.

CLIENT. Figurehead Records
DESIGNER. Jeff Matz
TOOLS. Illustrator, Photoshop

PAPER. Fox River Teton
PRINTING. Offset, silver ink,
special fold

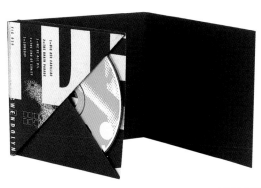

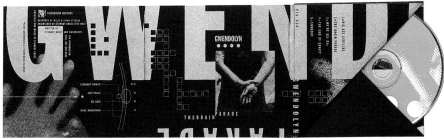

CLIENT. Figurehead Records
DESIGNER. Jeff Matz
TOOLS. Illustrator, Photoshop

PAPER. French Speckletone
PRINTING. Silkscreen, silver ink,
special fold

★★★Gwendolyn CD jacket
Lure Design, Inc.

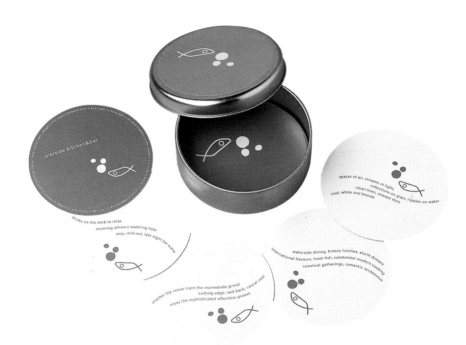

★★★Pierside media kit
Design Asylum Pte. Ltd.

CLIENT. Pierside Kitchen & Bar
ART DIRECTOR. Christopher Lee
DESIGNER/ILLUSTRATOR. Kai

TOOLS. Freehand, Macintosh
PAPER. Mirrorkote Sticker, Art Card
PRINTING. Metallic Ink

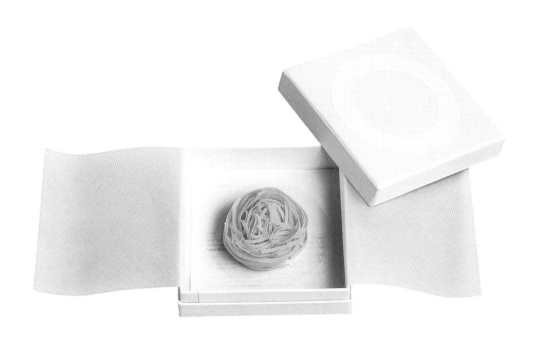

CLIENT. Rossi Ristorante/Enoteca
ART DIRECTOR. Christopher Lee
DESIGNER. Larry Peh

TOOLS. Freehand, Macintosh
PAPER. GSK Transparent/Maple Ivory
PRINTING. Metallic ink

★★★Rossi Ristorante opening
Design Asylum Pte. Ltd.

VOLUME
151

CHINO DUVET
100% BRUSHED COTTON
MACHINE WASH COLD
HOUSSE DE COUETTE/CHINO
100% COTON BROSSÉ
FABRIQUÉ EN CHINE
caban

ESSENTIAL FLAT SHEET/100% COTTON POPLIN
MACHINE WASH COLD. NO BLEACH
TUMBLE DRY MEDIUM/NO IRON
caban
caban

ESSENTIAL PILLOWCASES
100% COTTON POPLIN
MACHINE WASH COLD
TUMBLE DRY MEDIUM
NO BLEACH/NO IRON
caban

caban

C

flannel sheet set includes a flat, fitted
and two pillowcases. made in turkey.
l'ensemble de draps de flanellette com-
prend : un drap plat, un drap-housse et
deux taies d'oreiller. fabriqué en turquie.

caban

***Caban packaging
Bløk Design

CLIENT. Caban
ART DIRECTOR.
Vanessa Eckstein

DESIGNERS. Vanessa
Eckstein, Frances
Chen, Stephanie Yung

TOOLS. Illustrator, Macintosh
PAPER. Hammermill Via
PRINTING. C.J. Graphics

ENTIAL PILLOWCASES

SET OF TWO / MADE IN INDIA

% COTTON POPLIN

WASH DARK COLOURS SEPARATELY.

CHINE WASH COLD

MBLE DRY MEDIUM

BLEACH / NO IRON

caban

caban

caban

L'EAU FROIDE. NE PAS REPAS

SÉCHER PAR CULBUTAGE À MOYENNE TEMPÉRATURE

LAVER À LA MACHIN

NE PAS UTILISER D'AGENT DE BLANCHIMENT.

100% POPELINE DE CO

LAVER LES COULEURS FONCÉES SÉPARÉMENT.

ENSEMBLE DE DE

FABRIQUE EN INDE

CH

100% BR

WASH D

MACHIN

HOUSSE D

LAVER À LA MACHINE À L

100% CO

SÉCHER PAR CULBU

FABRIC

★★★Observatory Mansions
Pylon Design, Inc.

CLIENT. Random House of Canada
ART DIRECTOR. Scott Christie
DESIGNERS. Scott Christie, Gary Clement

TOOLS. Pencil, QuarkXPress, Macintosh
PAPER. Matte Coated

superdrug

?regnancy test

1 test • 99% Accurate • Result in 4 minutes

CLIENT. Superdrug DESIGNER. Clare Poupard
ART DIRECTOR. Garrick Hamm PRINTING. Lithography

★★★Pregnancy test packaging

Williams Murray Hamm

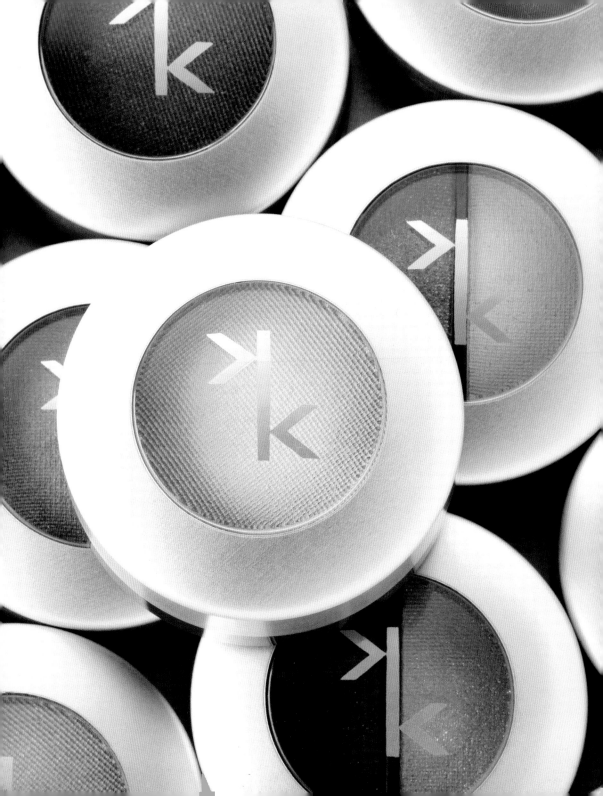

CLIENT. Superdrug
ART DIRECTORS. David Turner, Bruce Duckworth

DESIGNER. Janice Davison
TOOLS. Freehand, Macintosh

★★★Kolor packaging
Turner Duckworth

VOLUME
157

★★★Actia invite

Actia

CLIENT. Actia
ART DIRECTOR/DESIGNER. Anne-Lise Dermenghem
TOOLS. Illustrator, QuarkXPress

PAPER. Thibièrge Évanescent,
Comar
PRINTING. Aquaform

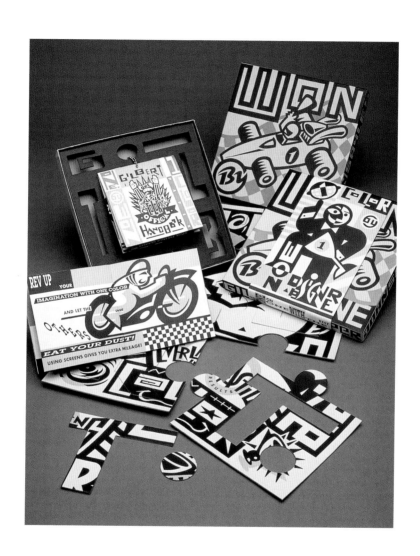

CLIENT. Gilbert Paper
ART DIRECTOR/DESIGNER/
ILLUSTRATOR. John Sayles

TOOLS. Illustrator, Macintosh
PAPER. Gilbert Oxford
PRINTING. Offset

★★★"One by One" paper promo!
Sayles Graphic Design

★★★Alyson's Valentine promo

Elixir Design

CLIENT. Dickson's, Inc.
ART DIRECTOR. Jennifer Jerde
DESIGNER. Nathan Durrant

PAPER. Crane's Kid Finish
Pearl White 134#
PRINTING. Engraved bisque

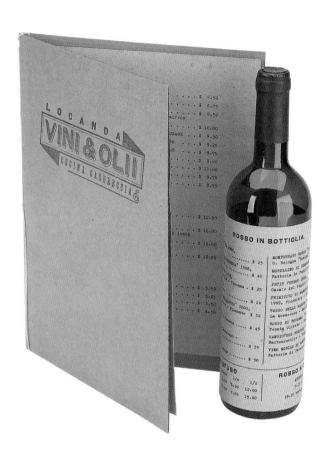

CLIENT. Locanda Vini & Olii
ART DIRECTOR. Matteo Bologna
DESIGNERS. Andrea Brown, Matteo Bologna

TOOLS. Freehand, Macintosh
PRINTING. Sioux Printing

★★★Locanda Vini & Olii

Mucca Design

★★★Volleyball book
Jennifer Sterling Design

CLIENT. Regis
ART DIRECTOR/DESIGNER. Jennifer Sterling
PHOTOGRAPHER. Marko Lavrisha
TOOLS. Illustrator, Photoshop
PAPER. Fox River
PRINTING. H. MacDonald Printing

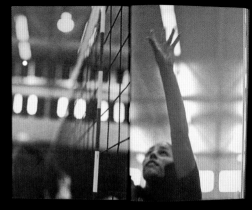

Celebrating
50 years
of chocolate
kuhnsumption

★★★Inkuhnabula Bon-bon box

Liska & Associates

CLIENT. Alyson Kuhn
ART DIRECTOR. Steve Liska
DESIGNER. Christina Nimry
PAPER. Light Impressions
Slide Box
PRINTING. Letterpress

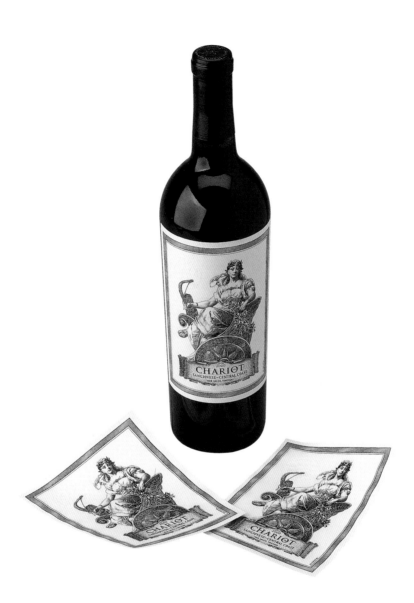

CLIENT. Jim Neal Wines
ART DIRECTOR. Tony Auston
DESIGNERS. Tony Auston, Chaim
Blomquist, Don Whelan

ILLUSTRATOR. David Laverty
TOOLS. Illustrator, Macintosh
PAPER. Mohawk Superfine Softwhite
PRINTING. Dickson's, Inc.

★★★Chariot Wine label

Auston Design Group

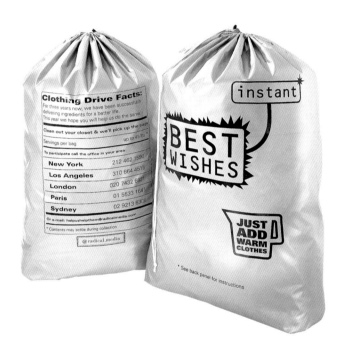

Clothing Drive Facts:
For three years now, we have been successfully
delivering ingredients for a better life.
This year we hope you will help us do the same.

Clean out your closet & we'll pick up the bags.

Servings per bag up to 45 lbs. *

To participate call the office in your area:

New York 212 462 1590
Los Angeles 310 664 4515
London 020 7432 6801
Paris 01 5533 1641
Sydney 02 9213 6308

Or e-mail: helpushelpthem@radicalmedia.com

* Contents may settle during collection

@radical.media

instant*

BEST WISHES

JUST ADD WARM CLOTHES

* See back panel for instructions

***Instant Best Wishes
@radical.media

CLIENT. @radical.media
ART DIRECTOR/DESIGNER. Rafael Esquer
COPYWRITERS. Angela Fung, Geoff Reinhard
MATERIALS. Canvas Drawstring Bag
TOOLS. Illustrator, Macintosh
PRINTING. Silkscreen,
Porcupine Products

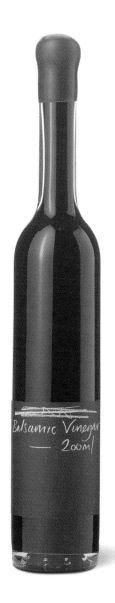

CLIENT. Heals
ART DIRECTOR. Garrick Hamm

DESIGNER/ILLUSTRATOR. Fiona Curran
PRINTING. Lithography

★★★Balsamic Vinegar

Williams Murray Hamm

CDA COLLECTION

One-Color Work from Chen Design Associates

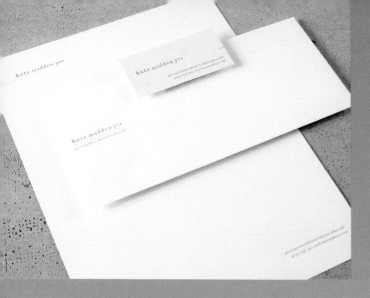

■***Kate Madden
Yee identity

170

CLIENT: Kate Madden Yee
ART DIRECTOR: Josh Chen
DESIGNER: Kathryn Hoffman

TOOLS: QuarkXPress, Macintosh
PAPER: Champion Benefit
PRINTING: Full Circle Press

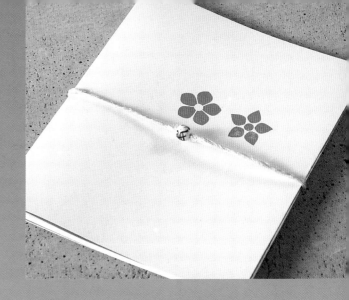

CLIENTS. Jacqueline Quintanilla, Albert Lin
DESIGNER. Max Spector
TOOLS. Illustrator, QuarkXPress, Macintosh

MATERIALS. French Frostone, Crane's Kid Finish, Handmade Paper, Twine, Bead
PRINTING. Full Circle Press (letterpress), Rubber hand stamp (red)

***Quintanilla & Lin wedding invitation

171

***CED News
alumni
magazine

CLIENT. College of Environmental Design,
UC Berkeley

ART DIRECTORS. Kathryn Hoffman, Josh Chen

DESIGNERS. Max Spector, Kathryn Hoffman

TOOLS. Illustrator, Photoshop, QuarkXPress,
Macintosh

PAPER. 60# Hammermill Accent Opaque Lustre White

PRINTING. UC Printing Services

JOSEPH ESHERICK
1914–1998

PAPER. Curious Popset,
Crane's Crest
PRINTING. Full Circle Press

CLIENT. Maya Spector
DESIGNER. Max Spector
TOOLS. Illustrator, Macintosh

174

***Maya Spector
identity

Maya Spector 3751 Bay Road, Menlo Park, CA 94025

Maya Spector

Maya Spector

oral traditions

STORYTELLING
POETRY
RITUAL

mayaspector@hotmail.com 650 329 1415

CLIENT. The Walden School
ART DIRECTOR. Josh Chen
DESIGNERS. Josh Chen, Max Spector,
 Christopher DeWinter

TOOLS. Illustrator, Photoshop, QuarkXPress,
 Macintosh
PAPER. Finch
PRINTING. Oscar Printing Company

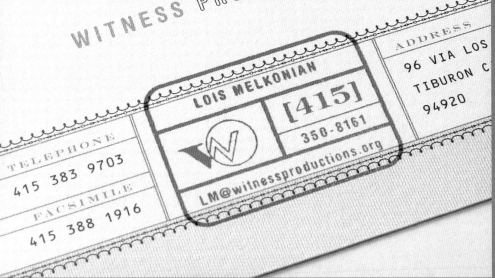

WITNESS PRODUCTIONS

LOIS MELKONIAN

[415]

350-8161

LM@witnessproductions.org

TELEPHONE
415 383 9703

FACSIMILE
415 388 1916

ADDRESS
96 VIA LOS
TIBURON C
94920

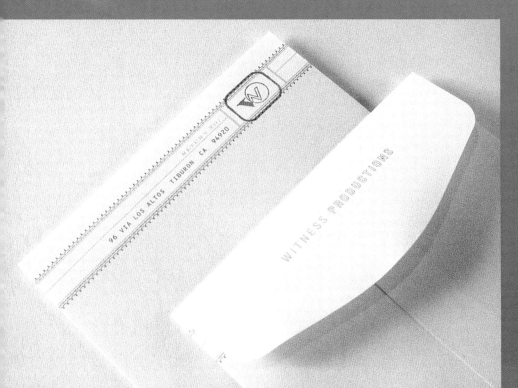

WITNESS PRODUCTIONS

96 VIA LOS ALTOS TIBURON CA 94920

CLIENT. Witness Productions, LLC
ART DIRECTOR. Josh Chen
DESIGNER. Max Spector
TOOLS. Illustrator, Macintosh

PAPER. Strathmore Pure Cotton
PRINTING. Oscar Printing Company (offset),
Rubber hand stamp (red)

2-COLOR

two-color is

dynamic, elegant, edgy, bold, compelling, simple, stylish, financially liberating, creatively stimulating, challenging.

GRAPHICS

T.B. D. HOW-TO

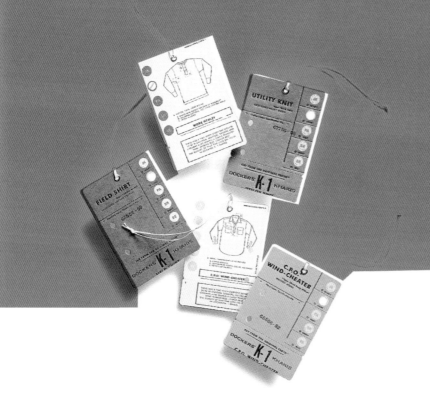

Two-Color Design Work by Templin Brink Design

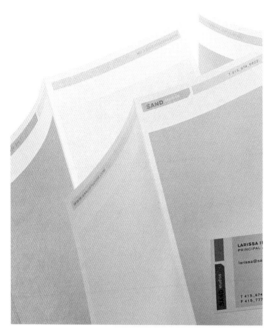

SAND STUDIOS STATIONERY

Sand Studios is an architectural design firm that combines different textures of glass and metal in the spaces they develop. Their stationery system reflects some of those same qualities through the use of translucent paper printed with two colors on each side. The graphic elements that show through from the back and interact with the designs on the front are carefully arranged to create depth and give the illusion that more than two colors were used in printing the piece.

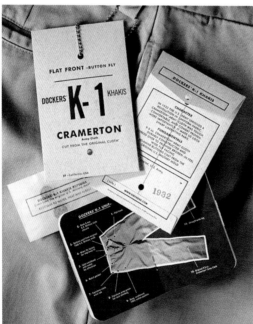

DOCKERS K-1 KHAKIS PACKAGING

The packaging system for Dockers K-1 Khakis was not developed in two colors because of budget restrictions, but rather because it was the right look for the concept that was inspired by 1930s military paraphernalia. Most of the pertinent information in this packaging system was printed in black only. The second color was either used as a small accent, such as a date stamp, or as a flood of color that distinguished the various fits.

UNITED AIRLINES *HEMISPHERES* MAGAZINE

Sometimes we like to use minimal colors to give a piece an understated elegance. In the case of the cover for December's *Hemispheres* magazine, the white space is an integral part of the design and acts as a third color.

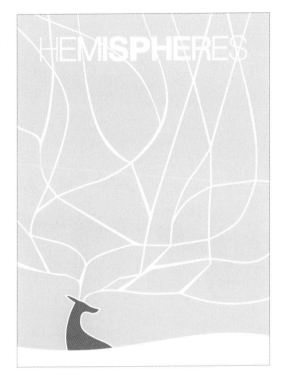

KEA BUSINESS CARD

This specialty print broker wanted to showcase his capabilities through his business card. The metal card is silk screened with two tightly registered colors, embossed, and die cut, while his personal information is offset printed on a sticker.

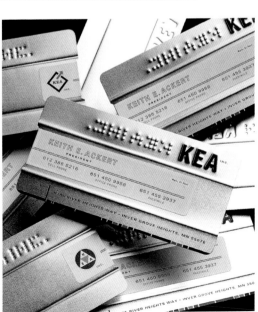

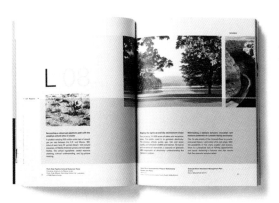

EDAW CORPORATE BROCHURE

In designing this brochure, we took full advantage of the fact that we were going to have multiple signatures to work with on press. We carefully laid out each signature so that the pagination resulted in colors alternating from one spread to the next, making it an eight-color brochure instead of two. Cleaning out one unit of the press between forms is a minimal cost to achieve a great effect.

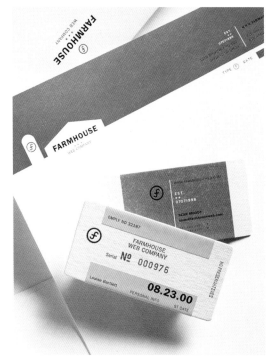

FARMHOUSE WEB CO. STATIONERY

For Farmhouse Web Co., a high tech firm with a low tech name, we used a palette of John Deere colors that alternated from one component to the next. While each piece in the stationery system utilized black, the accompanying color was switched out on each print run. The business cards were stamped with automated serial numbers, a very cost effective fun factor. Personal information was laser imprinted onto pre-printed, kiss-cut stickers that were then wrapped around the generic cards.

SEAGATE PRINT ADVERTISING

We printed this advertising campaign as black and a metallic spot green, emphasizing Seagate's corporate colors. Some of the black was specified to overprint, some to knock out, and some to print as a screen. These varying effects over the metallic color achieved an unusual illusion of depth.

VANDOMMELEN COLORWORKS BUSINESS CARDS

To maximize the print run on this letterhead system for a color consultant, we printed a series of different two-color die-cut stickers that were applied to his letterhead, envelope, business cards, and paint cans. For the business cards, we cut down actual paint chips from our client's color library which provided him with an endless rainbow of cards that perfectly captured his services.

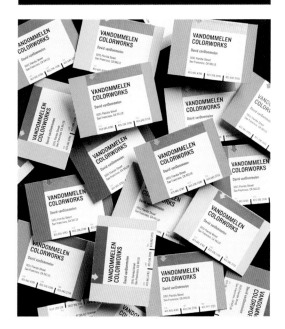

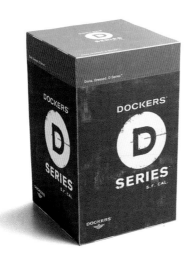

DOCKERS D-SERIES P.O.S.

As is often the case with industrially inspired designs, the Dockers D-series brand is limited to two colors for conceptual reasons. Sometimes simple is better.

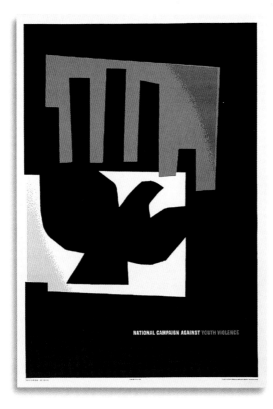

NATIONAL CAMPAIGN AGAINST YOUTH VIOLENCE POSTER

The National Campaign Against Youth Violence poster uses bold colors printed on a dark cream stock, which is perceived as a third color. A light screen of black that is overprinting some areas of the orange and cream adds additional richness and depth to the piece.

TEMPLIN BRINK DESIGN ANNOUNCEMENT

For our moving announcements, we created industrially inspired typographic design elements silk screened on a heavy-duty cardstock. The combination of design, printing technique, and material made for a piece that didn't get lost in the mail.

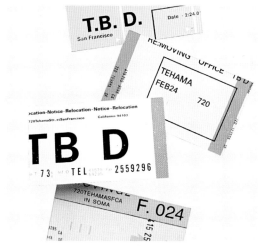

OAKLAND A'S ADS

This series of ads for the Oakland A's was created to look like an election campaign from the '50s. The use of crude screen patterns and overprinting colors are classic techniques to capture the spirit of that era.

MACLEAN WINERY BOTTLE

For this wine bottle featuring the kilt of the clan MacLean, we incorporated the bottle color as the third color in the pattern design.

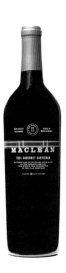

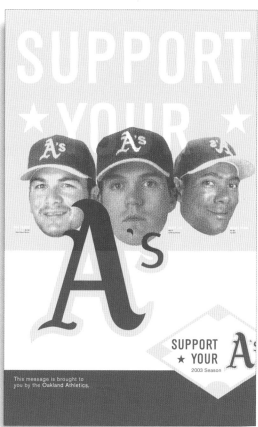

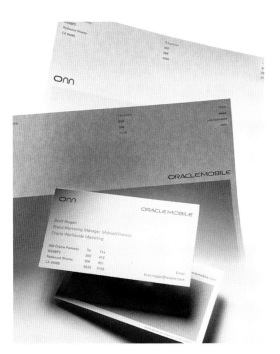

ORACLEMOBILE STATIONERY

The OracleMobile letterhead features two colors on the front and a block of solid color on the back, printed in either light blue or red. The paper is slightly translucent so that the color from the back frames the placement of the text on the front.

TARGET ARCHER FARMS PACKAGING

The design architecture of this packaging system for Target's high-end food brand, Archer Farms, is entirely built off of the leaf shape of the logo. Each product package features one main color and is accented with either a die-cut window that reveals the food within or a pattern that is made up of screens of the primary color.

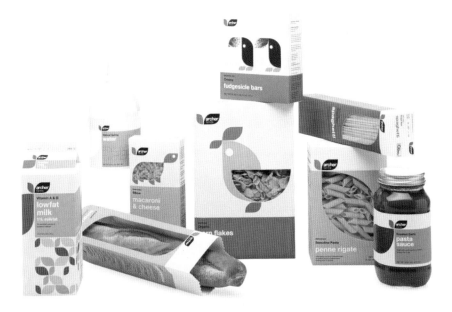

AMERICAN EAGLE OUTFITTERS
CREDIT CARD

The American Eagle Clear Card design adds dimension to its minimal colors by having translucent and opaque areas interact in interesting ways.

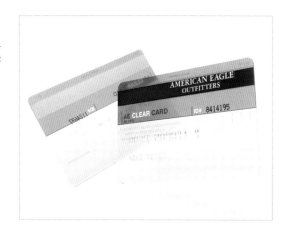

"T.B. D. IN IOWA" AND "JANUARY" POSTERS

In both of these posters, we printed a grayscale image that we accented with blocks of overprinted colors to achieve a desired mood. In some places the second color is printed solid, in others as a screen.

TEMPLIN BRINK DESIGN STATIONERY

To maximize the amount of color combinations in our own stationery system, we created one engraving plate that we used throughout while switching out paper stocks and sometimes changing inks mid-run.

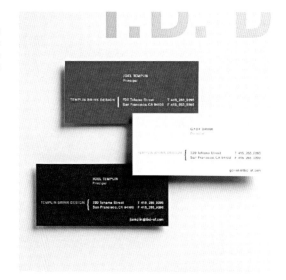

IDENTITY

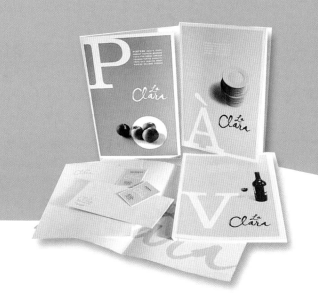

letterhead / business cards / envelopes / logos

DESIGN FIRM	ART DIRECTOR	DESIGNER	CLIENT	TOOLS	PAPER/MATERIAL	COLORS USED	PRINTER INFO
WPA Pinfold	Hayley Wall	Hayley Wall	Vertical Drinks Ltd.	Freehand QuarkXPress	Gmond's Bier Papier	PMS 4625 PMS 484	GKK Print

DESIGN FIRM	CLIENT	TOOL
Power Graphixx	Trouper	Adobe Illustrator

DESIGN FIRM	ART DIRECTOR	DESIGNER	CLIENT	TOOLS	PAPER/MATERIAL
Heads Inc.	So Takahashi	So Takahashi	Heads Inc.	QuarkXPress	Plexi

Heads Inc.
So Takahashi
526 West 26th Street Suite 211 New York, NY 10001
Tel: 212 243 4102 Fax: 212 243 5544
email: soso@bway.net

DESIGN FIRM	ART DIRECTOR	DESIGNER	CLIENT	TOOL	PAPER/MATERIAL	COLORS USED	PRINTER INFO
Character	Rishi Shourie	Rishi Shourie	Danger Inc.	Adobe Illustrator	Starwhite Vicksburg	PMS 1665 PMS 424	Digital Engraving, Inc.

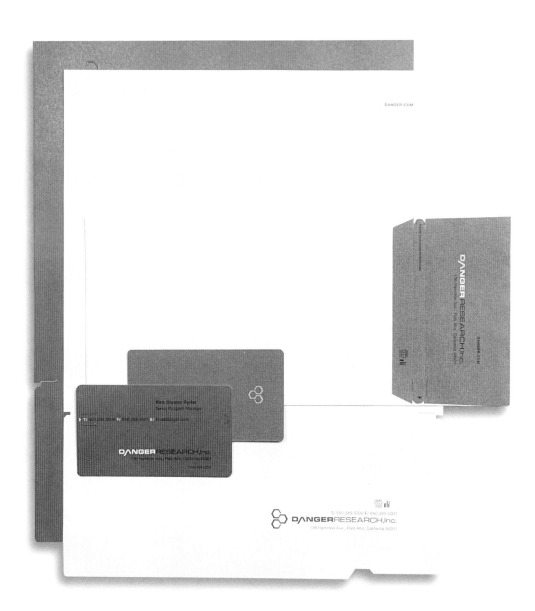

DESIGN FIRM	ART DIRECTOR	DESIGNER	CLIENT	PRINTER INFO
So Design Co.	Aaron Pollock	Aaron Pollock	Rob Pollock	Nomadic Press

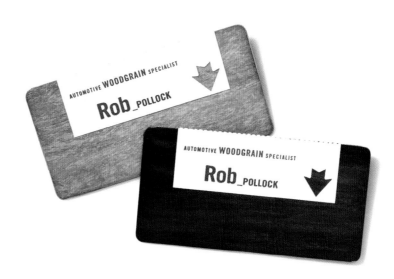

DESIGN FIRM	ART DIRECTORS	DESIGNERS	CLIENT	TOOL	PAPER/MATERIAL	COLORS USED	PRINTER INFO
R2 Design	Lizá Defossez Ramalho Artur Rebelo	Lizá Defossez Ramalho Artur Rebelo	MN Arquitectos	Freehand	Couché Matte	PMS 544 PMS 497	Minerva

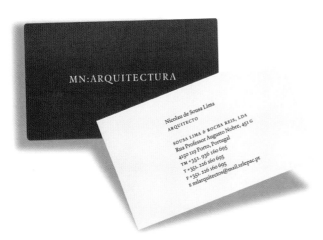

DESIGN FIRM	ART DIRECTORS	DESIGNERS	CLIENT	COLORS USED
BC Design	David Bates Mike Calkins	Mike Calkins David Bates	Dankens	Business Card: PMS 9223 / PMS 4695 Stationery: PMS 9583 / PMS 4695

DESIGN FIRM	ART DIRECTOR	DESIGNER	CLIENT	TOOL	COLORS USED
Up Design Bureau	Chris Parks	Chris Parks	Mel Updegraf	Freehand	PMS 152 Black

DESIGN FIRM	ART DIRECTOR	DESIGNERS	CLIENT	COLORS USED	PRINTER INFO
Werner Design Werks	Sharon Werner	Sharon Werner Sarah Nelson	Grand Connect	Green Brown	Exceptional Engraving

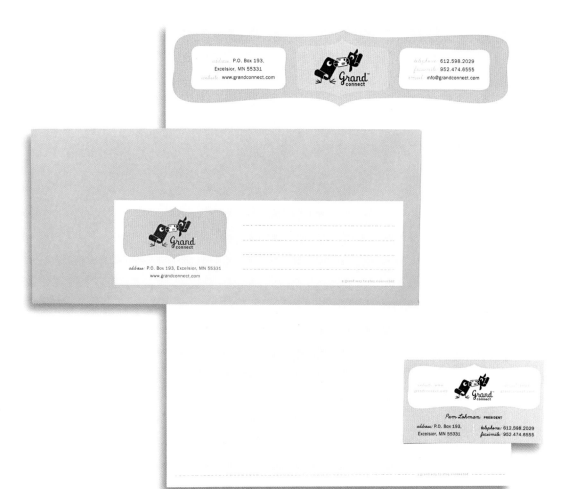

DESIGN FIRM	ART DIRECTOR	DESIGNERS	CLIENT	TOOLS	PAPER/MATERIAL	COLORS USED	PRINTER INFO
Imagehaus	Jay Miller	Stuart Flake Jay Miller	Schmidty's	Adobe Illustrator QuarkXPress	Mr. French Construction	PMS 173 PMS 459	Print Craft

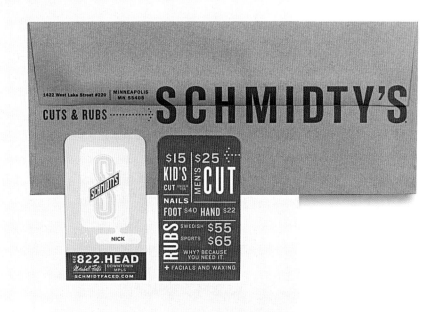

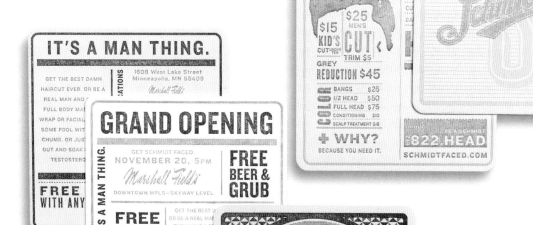

DESIGN FIRM	ART DIRECTOR	DESIGNER	CLIENT
Peñabrand	Luis Peña	Luis Peña	Peñabrand

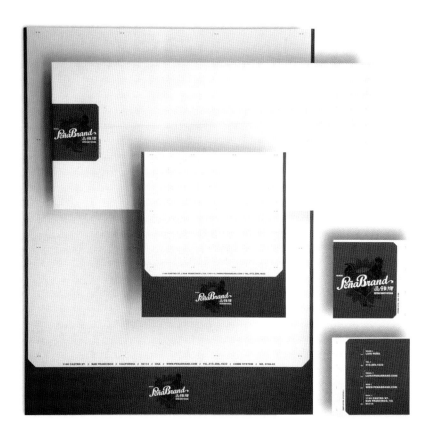

DESIGN FIRM	ART DIRECTOR	DESIGNER	CLIENT	TOOL	PAPER/MATERIAL	COLORS USED	PRINTER INFO
Duffy Singapore	Christopher Lee	Kai Yeo	pop!con lifestyle	Freehand	Artcard with Gloss Varnish	PMS 384 PMS Cool Gray 9	National Photo Engravers, Singapore

DESIGN FIRM	ART DIRECTORS	DESIGNERS	CLIENT	TOOL	PAPER/MATERIALS	COLORS USED	PRINTER INFO
Catalyst Studios	Beth Mueller Jason Rysavy	Beth Mueller Steve Jockisch	Catalyst Studios	Adobe Illustrator	Giant Realm Smooth Carnival	PMS Metallic 8403 PMS 379	Commers Printing

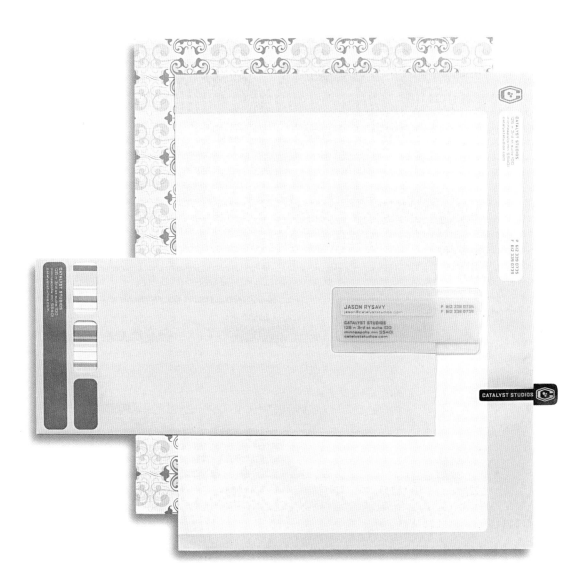

DESIGN FIRM	CLIENT	TOOL	COLORS USED	PRINTER INFO
Karlssonwilker inc.	Karlssonwilker inc.	Adobe Illustrator	Black White	Maendle Screen Printing

DESIGN FIRM	ART DIRECTOR	DESIGNERS	CLIENT	TOOL
Big Giant	Derek Welch	Derek Welch Jason Bacon	UNKL	Adobe Illustrator

DESIGN FIRM	ART DIRECTOR	DESIGNERS	CLIENT	TOOLS	PAPER/MATERIAL	COLORS USED	PRINTER INFO
Visual Dialogue	Fritz Klaetke	Fritz Klaetke Ian Varrassi	Nucleus Research	QuarkXPress Adobe Illustrator	Beckett Expressions	PMS 485 Black	Print Resource

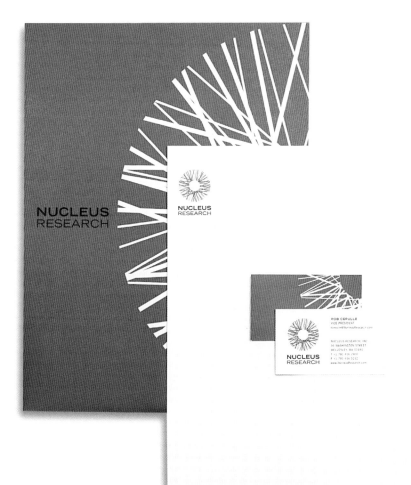

DESIGN FIRM	ART DIRECTOR	DESIGNER	CLIENT	TOOLS	COLORS USED	PRINTER INFO
Hybrid Design	Brian Flynn	Brian Flynn	Nike, Inc.	Adobe Illustrator Adobe Photoshop	PMS 382 Black	Formit

DESIGN FIRM	ART DIRECTORS	DESIGNERS	CLIENT	TOOLS	PAPER/MATERIALS	COLORS USED	PRINTER INFO
Hat-Trick Design Consultants	Jim Sutherland Gareth Howat David Kimpton	Jim Sutherland Gareth Howat David Kimpton	Rabih Hage	QuarkXPress Adobe Illustrator	White Wave Die-cut	PMS 411 PMS 413	Boss Print

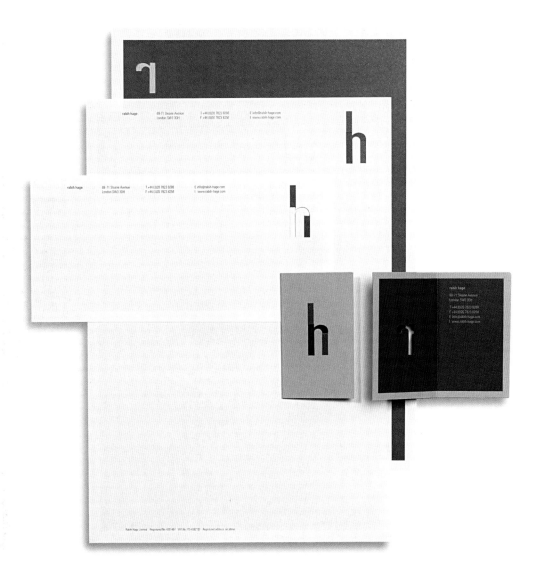

DESIGN FIRM	ART DIRECTOR	DESIGNER	CLIENT	TOOL	PRINTER INFO
Public	Todd Foreman	Todd Foreman	Radiate	Adobe Illustrator	Expressions Litho

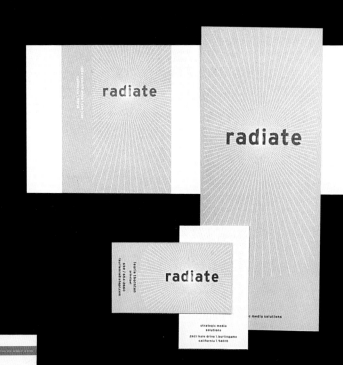

DESIGN FIRM	ART DIRECTOR	DESIGNER	CLIENT	TOOL	PAPER/MATERIAL	COLORS USED	PRINTER INFO
9MYLES, Inc.	Myles McGuinness	Myles McGuinness	9MYLES, Inc.	Adobe Illustrator Adobe Photoshop Sandpaper	Classic Crest 70# Text 120# Cover	PMS 1807 PMS 5435	Graphics Ink

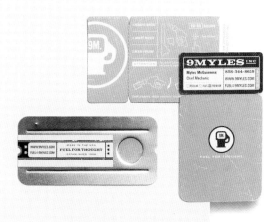

DESIGN FIRM	ART DIRECTOR	DESIGNER	CLIENT	TOOL	PAPER/MATERIALS	COLORS USED	PRINTER INFO
Duffy New York	Alan Colvin	David Mashburn	Fractal, LLC	Adobe Illustrator	Fox River Paper Starwhite Tiara	PMS 116 PMS 168	InterLect Color

DESIGN FIRM	ART DIRECTOR	DESIGNERS	CLIENT	COLORS USED	PRINTER INFO
Werner Design Werks	Sharon Werner	Sharon Werner Sarah Nelson	TV by Girls	Tape: Blue/Olive Business Card: Black/Rubber Stamp	Exceptional Engraving

DESIGN FIRM	ART DIRECTOR	DESIGNER	CLIENT	TOOLS	PAPER/MATERIAL	COLORS USED
KO	Pol Baril	Maxime Lévesque	IDX	Adobe Illustrator Adobe Photoshop	Tango 24 pt. Matte Varnish	PMS 541 PMS 021

DESIGN FIRM	ART DIRECTOR	DESIGNER	CLIENT	TOOL	PAPER/MATERIAL	COLORS USED	PRINTER INFO
And Partners, Inc.	David Schimmel	Tyler Small	B.Hive Productions	Adobe Illustrator	Mohawk Superfine Options	PMS 110 PMS 161	Dickson's Atlanta

DESIGN FIRM	ART DIRECTOR	DESIGNER	CLIENT	TOOL	COLORS USED
Up Design Bureau	Chris Parks	Chris Parks	Nick McClure	Freehand	PMS 124 Black

DESIGN FIRM	ART DIRECTOR	DESIGNERS	CLIENT	TOOLS	PAPER/MATERIAL
SJI Associates	Jill Vinitsky	Karen Lemcke G T Goto	SJI Associates	Adobe Illustrator QuarkXPress	Smart Papers Benefit

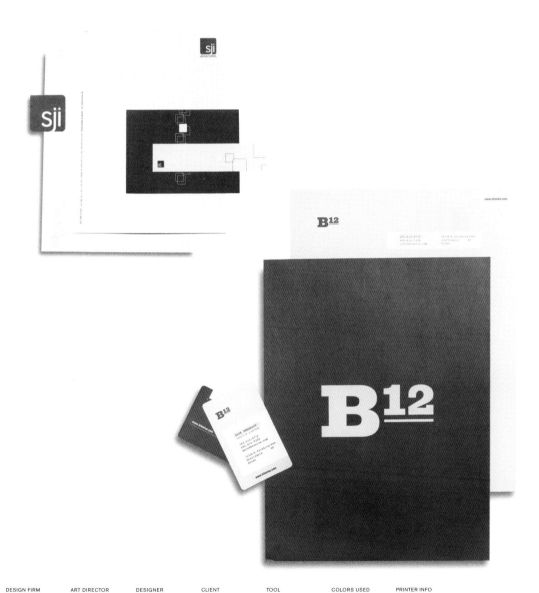

DESIGN FIRM	ART DIRECTOR	DESIGNER	CLIENT	TOOL	COLORS USED	PRINTER INFO
B^{12}	Dave Prescott	Dave Prescott	B^{12}	Adobe Illustrator	PMS 179 PMS 454	Alegra

DESIGN FIRM	ART DIRECTOR	DESIGNER	CLIENT	TOOL	PAPER/MATERIALS	COLORS USED	PRINTER INFO
Elixir Design	Jennifer Jerde	Aaron Cruse	Credit Records	Adobe Illustrator	Greenfield Hemp Heritage DuraPress Speckletone	Black Brown	Valencia Printing

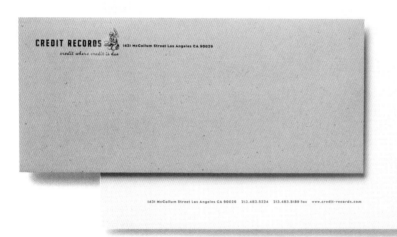

DESIGN FIRM	ART DIRECTOR	DESIGNER	CLIENT	TOOL	COLORS USED
Up Design Bureau	Chris Parks	Chris Parks	Ariagno & Kerns	Freehand	PMS 469 PMS 3308

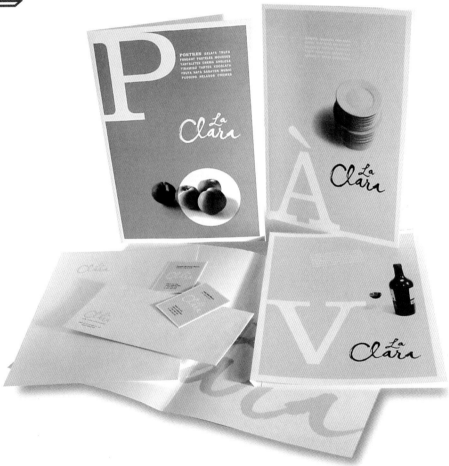

DESIGN FIRM	ART DIRECTOR	DESIGNER	CLIENT	TOOL	PAPER/MATERIAL	COLORS USED	PRINTER INFO
Sonsoles Llorens	Sonsoles Llorens	Sonsoles Llorens	La Clara Restaurant	Freehand	Coated Paper Matte Laminated & Varnished	PMS 7528 / Black PMS 645 / Black	Agal

DESIGN FIRM	ART DIRECTOR	DESIGNER	CLIENT	TOOL	PAPER/MATERIAL	COLORS USED	PRINTER INFO
And Partners, Inc.	David Schimmel	Charisse Gibilisco	Steelcase Design Partnership	Adobe Illustrator	Strathmore Elements	PMS 7 / PMS 641 PMS 7 / PMS 109 PMS 7 / PMS 390 PMS 7 / PMS 021	Dickson's Atlanta

DESIGN FIRM	ART DIRECTOR	DESIGNER	CLIENT	TOOL	COLORS USED
8 BLU	Patrick Nistler	Patrick Nistler	Jonathan Miller	Adobe Illustrator	PMS 1525 PMS 109

DESIGN FIRM	ART DIRECTOR	DESIGNER	CLIENT	COLORS USED	PRINTER INFO
So Design Co.	Aaron Pollock	Aaron Pollock	Right-A-Way Applicators	Process Red Process Blue	Shapco Printing

Stationery samples with "NEIDHARDT" logo.

2851 Spring Street
Redwood City
CA 94063

NEIDHARDT

2851 Spring Street
Redwood City
CA 94063

NEIDHARDT

650 596 8628 ph
650 596 8628 fx

FRANK NEIDHARDT
frank@neidhardts.com

ART DIRECTOR	DESIGNER	CLIENT	TOOL	PRINTER INFO
Todd Foreman	Todd Foreman	Neidhardt	Adobe Illustrator	Expressions Litho

DESIGN FIRM	ART DIRECTORS	DESIGNER	CLIENT	TOOLS	COLORS USED
BC Design	David Bates Mike Calkins	Pat Snavely	Astar	Freehand	PMS 147 PMS 545

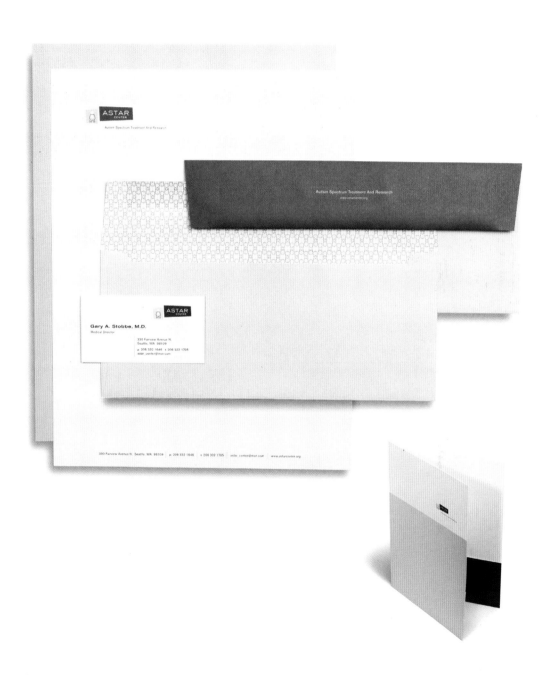

DESIGN FIRM	ART DIRECTOR	DESIGNER	CLIENT	TOOL	PAPER/MATERIAL	COLORS USED	PRINTER INFO
Catalyst Studios	Jason Rysavy	Ben Levitz	Chef Kevin Cullen Goodfellow's restaurant	Adobe Illustrator	Letterpress	Orange Brown	Studio On Fire

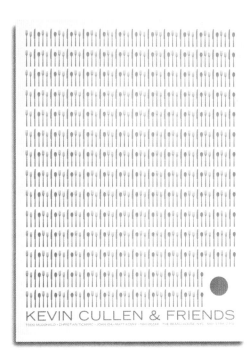

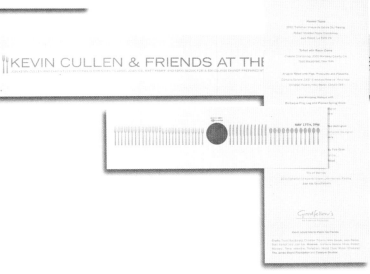

DESIGN FIRM	ART DIRECTOR	DESIGNER	CLIENT	TOOLS
Paprika	Louis Gagnon	Rene Clement	Verses Restaurant	Adobe Illustrator QuarkXPress

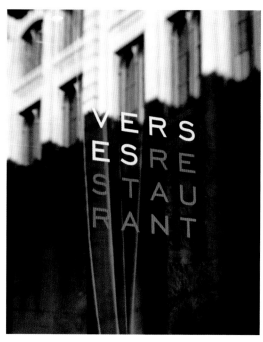

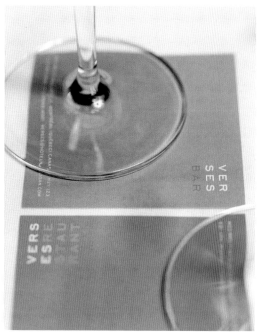

DESIGN FIRM	CLIENT	TOOL
Power Graphixx	Wabi:Sabi	Adobe Illustrator

R/AW

U.S.A.

RIGHT-A-WAY APPLICATORS, INC
281 COUNTY ROAD 19, COOPERSTOWN

ND 58425.
U.S.A.

R/AW

281 COUNTY ROAD 19
COOPERSTOWN

ND 58425.
U.S.A.

PRESIDENT
DAVID R MATSON

OFFICE TEL. 701-797 3322 OFFICE FAX 701-797 3323 HOME 701-797 3348

OFFICE TELEPHONE 701-797 3322 OFFICE FACSIMILE 701-797 3348

DESIGN FIRM	ART DIRECTOR	DESIGNER	CLIENT	TOOLS	COLORS USED
Duffy Minneapolis	Dan Olson	Dan Olson	Hayward Hawks	Adobe Illustrator	PMS 185 2x Black

DESIGN FIRM	CLIENT	TOOLS
Power Graphixx	Trouper	Adobe Illustrator

COLLATERAL

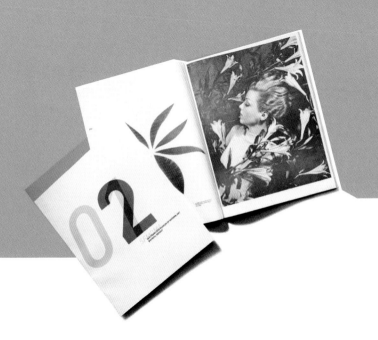

annual reports / brochures / magazines / campaigns /
direct mail / promotions

DESIGN FIRM	ART DIRECTORS	DESIGNERS	CLIENT	TOOLS	PAPER/MATERIAL	COLORS USED	PRINTER INFO
Hat-Trick Design Consultants	Jim Sutherland Gareth Howat David Kimpton	Jim Sutherland Jamie Ellul Mark Wheatcroft	Fairbridge	QuarkXPress Adobe Photoshop	Redeem	PMS 021 Black	Boss Print

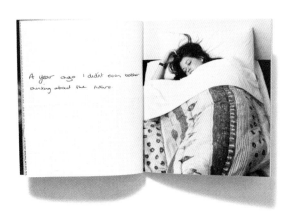

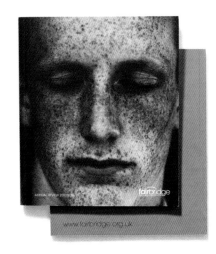

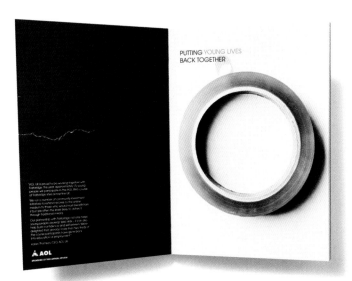

DESIGN FIRM	ART DIRECTORS	DESIGNERS	CLIENT	TOOLS	PAPER/MATERIALS	COLORS USED	PRINTER INFO
Hat-Trick Design Consultants	Jim Sutherland Gareth Howat David Kimpton	Jim Sutherland Jamie Ellul	Fairbridge	QuarkXPress Adobe Photoshop	Challenger Offset Command matte	PMS 182 PMS 324	Boss Print

DESIGN FIRM	ART DIRECTOR	DESIGNERS	CLIENT	TOOLS	PAPER/MATERIALS	COLORS USED	PRINTER INFO
what!design	Damon Meibers	Typeface Nicolas Ng Mike Koid Illustrators Eddie Martinez Derek Aylward	AIGA/Boston	QuarkXPress Adobe Photoshop	Carnival Green Stone 80# Cover Carnival Gray and Ivory 70# Text	PMS 202 PMS 144	Deschamps Printing

DESIGN FIRM	ART DIRECTOR	DESIGNER	CLIENT	TOOLS	COLORS USED
Liquid Agency Inc.	Joshua Swanbeck	Joshua Swanbeck	ICA	QuarkXPress Adobe Photoshop	PMS Orange Black

The Monotype Marathon is an intensive weekend of workshops held in professional printmaking studios throughout the Bay Area and led by accomplished monotype artists. During the workshops, artists produce a number of prints, the best of which included in an exhibition at the IC end of the three-week show, the exhibition are auctioned help support the K

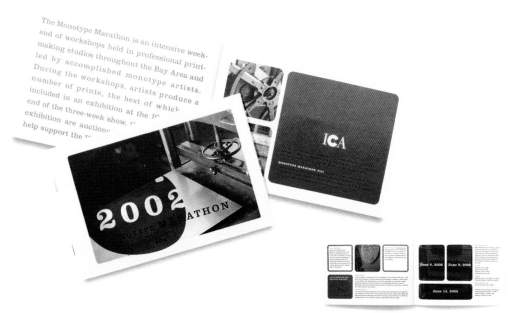

DESIGN FIRM	ART DIRECTOR	DESIGNER	CLIENT	TOOLS	PAPER/MATERIAL	COLORS USED	PRINTER INFO
Storm Visual Communications Inc.	Robert Smith	Robert Smith	The Ottawa Hospital Foundation	QuarkXPress Adobe Photoshop	Rolland Opaque Stickers	PMS 544 Black	Custom Printers of Renfrew Ltd.

DESIGN FIRM	DESIGNER	CLIENT	TOOL	PAPER/MATERIAL	COLORS USED	PRINTER INFO
Cheng Design	Karen Cheng	Seattle Arts & Lectures	QuarkXPress	Domtar Titanium 80# Text	PMS 151 PMS 5747	The Copy Company

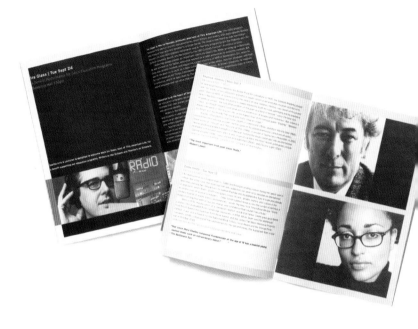

DESIGN FIRM	DESIGNER	CLIENT	TOOLS	PAPER/MATERIAL	COLORS USED	PRINTER INFO
Cheng Design	Karen Cheng	Seattle Arts & Lectures	QuarkXPress	Cougar 65# Cover	PMS 1935 PMS 5747	Olympus Press

DESIGN FIRM	ART DIRECTOR	DESIGNER	CLIENT	TOOL	PAPER/MATERIAL	COLORS USED	PRINTER INFO
Bamboo	Kathy Sovanno	Kathy Sovanno	Melanie Haroldson Judy Sovanno	Adobe Illustrator	Naturalis Gallery Silk Artic White Smooth	System 1: PMS 2717 / 021 System 2: PMS 7478 / 1788	Diversified Graphics Inc.

DESIGN FIRM	ART DIRECTOR	DESIGNER	CLIENT	TOOLS	COLORS USED	PRINTER INFO
Kolegram Design	Gowtran Blais	Gowtran Blais	UNESCO Canada	QuarkXPress Adobe Photoshop Adobe Illustrator	PMS 021 Black	Gilmore Printing

DESIGN FIRM	ART DIRECTORS	DESIGNERS	CLIENT	TOOLS	PAPER/MATERIALS	COLORS USED	PRINTER INFO
Turner Duckworth San Francisco and London	David Turner Bruce Duckworth	David Turner Bruce Duckworth Christian Eager Anthony Biles	Turner Duckworth San Francisco and London	Adobe Illustrator Freehand	Lambskin with Foil Stamping 100# McCoy Uncoated Text	Black Red	Paper N Inc. Arnold's Bookbinding

DESIGN FIRM	ART DIRECTOR	DESIGNER	CLIENT	TOOLS	COLORS USED
Emery Vincent Design	Emery Vincent Design	Emery Vincent Design	Sydney Cancer Centre	QuarkXPress Adobe Illustrator	PMS 2583 PMS 300

DESIGN FIRM	ART DIRECTOR	DESIGNER	CLIENT	TOOL	PAPER/MATERIALS	COLORS USED	PRINTER INFO
Ostrauh Design Studio	Nikolay P. Ivanenko	Nikolay P. Ivanenko	Elektrosviaz	Freehand	Gavana Arena 100g Gannover 300g	PMS 021 PMS 5825	HP Color Laser Jet 4550

DESIGN FIRM
Adi Stern Design

DESIGNERS
Adi Stern
Dorit Berlin
Reshef

CLIENT
Israeli Ministry
of Culture

TOOL
Freehand

PAPER/MATERIALS
Uncoated Paper
Hardcover

COLORS USED
Black
Cyan

PRINTER INFO
Kal Press Ltd.

DESIGN FIRM	ART DIRECTOR	DESIGNER	CLIENT	TOOLS	PAPER/MATERIALS	PRINTER INFO
Wilson Harvey: London	Paul Burgess	Paul Burgess	CCD / Metrologie	Adobe Illustrator QuarkXPress	150g Matte Artbord Glued to 1500 Micron Pulp Board Matte Laminate	Hythe Offset, England

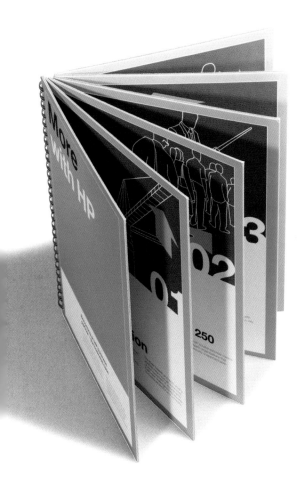

DESIGN FIRM	ART DIRECTOR	DESIGNER	CLIENT	TOOLS	PAPER/MATERIAL	COLORS USED
Kilter	Cynthia Knox	Travis Olson	Kilter	Adobe Photoshop Adobe Illustrator	Vinyl	White Orange

DESIGN FIRM	ART DIRECTOR	DESIGNERS	CLIENT	TOOLS	PRINTER INFO
Public	Todd Foreman	Todd Foreman Tessa Lee Nancy Thomas Lindsay Wheeler	Heyday Books	QuarkXPress	Oceanic Graphic Printing, Inc.

DESIGN FIRM	ART DIRECTOR	DESIGNERS	CLIENT	TOOLS	PAPER/MATERIALS	COLORS USED	PRINTER INFO
Blok Design	Vanessa Eckstein	Vanessa Eckstein Mariana Contegni	Nike, Inc.	Adobe Illustrator Adobe Photoshop	Starwhite Tiara Key Color	PMS 877 PMS 549	Artes Graphicas Panorama

DESIGN FIRM	ART DIRECTOR	DESIGNER	CLIENT	TOOLS	COLORS USED	PRINTER INFO
BBK Studio	Sharon Oleniczak	Sharon Oleniczak	Mandira Gazal	QuarkXPress	PMS 578 PMS 152	Foremost Graphics

DESIGN FIRM	DESIGNER	CLIENT	TOOLS	PAPER/MATERIAL	COLORS USED	PRINTER INFO
Cheng Design	Karen Cheng	*Arcade* magazine	QuarkXPress Adobe Illustrator Adobe Photoshop	60# Text	PMS Warm Red Black	Consolidated Press

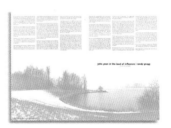

DESIGN FIRM	ART DIRECTOR	DESIGNER	CLIENT	TOOLS	PAPER/MATERIAL	COLORS USED	PRINTER INFO
Arkzin D.O.O.	Dejan Krsić	Dejan Krsić	Arkzin	Pagemaker	Videm Print 70g	Red Black	Tiskara Zelina

DESIGN FIRM	ART DIRECTOR	DESIGNER	CLIENT	COLORS USED	PRINTER INFO
Werner Design Werks	Sharon Werner	Sharon Werner	Wert & Co.	Card 1: Orange and Black Card 2: Blue and Black Card 3: Red and Black Card 4: Green and Black	Nomadic Press

ART DIRECTOR	DESIGNERS	CLIENT	TOOLS	PAPER/MATERIAL	COLORS USED	PRINTER INFO
Julie Freeman	Todd Houlette Mitch Morse	Surfrider Foundation	Adobe Illustrator Adobe Photoshop QuarkXPress	Cougar Opaque	PMS 133 PMS 290	Graphic Press

DESIGN FIRM	ART DIRECTOR	DESIGNERS	CLIENT	TOOLS	PAPER/MATERIAL	PRINTER INFO
Public	Todd Foreman	Todd Foreman Lindsay Wheeler	San Francisco Museum of Modern Art	QuarkXPress	Newsprint	Alonzo Printing

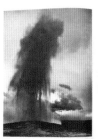

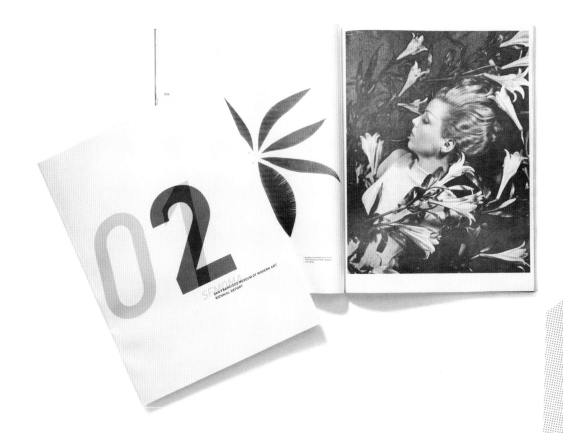

DESIGN FIRM	ART DIRECTOR	DESIGNER	CLIENT	TOOLS	PAPER/MATERIAL	COLORS USED	PRINTER INFO
Aufuldish & Warinner	Bob Aufuldish	Bob Aufuldish	California College of the Arts and Crafts	Adobe Photoshop Adobe Illustrator	Mohawk Navaho	Cyan Black	Oscar Printing

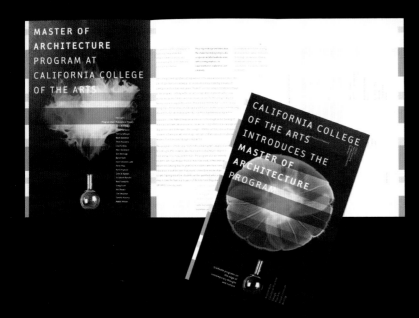

DESIGN FIRM	ART DIRECTOR	DESIGNER	CLIENT	TOOLS	PAPER/MATERIAL	COLORS USED	PRINTER INFO
Aufuldish & Warinner	Bob Aufuldish	Bob Aufuldish	California College of the Arts and Crafts	Adobe Photoshop Adobe Illustrator	Finch Opaque	PMS 381 Black	Oscar Printing

DESIGN FIRM	ART DIRECTOR	DESIGNERS	CLIENT	TOOL	PAPER/MATERIAL	COLORS USED	PRINTER INFO
Voice	Scott Carslake	Scott Carslake Anthony de Leo	Voice	QuarkXPress	Precision Laser	Cover PMS 5405 / 802 Text PMS 802 / Black	Finsbury Print

DESIGN FIRM	ART DIRECTOR	DESIGNER	CLIENT	TOOLS	COLORS USED	PRINTER INFO
Methodologie	Claudia Meyer- Newman	Sarina Montenegro	Federal Home Loan Bank of Seattle	QuarkXPress	PMS 166 PMS 4975	Colorgraphics

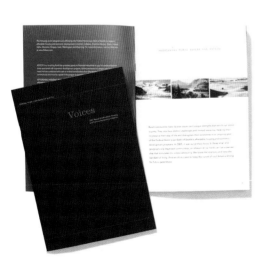

DESIGN FIRM	ART DIRECTOR	DESIGNER	CLIENT	TOOLS	PAPER/MATERIAL	COLORS USED	PRINTER INFO
Nicholas Associates	Nick Sinadinos	Nick Sinadinos	Unity Temple Restoration Foundation	QuarkXPress	Cougar Matte	PMS 611 Black	Arby-Imagine

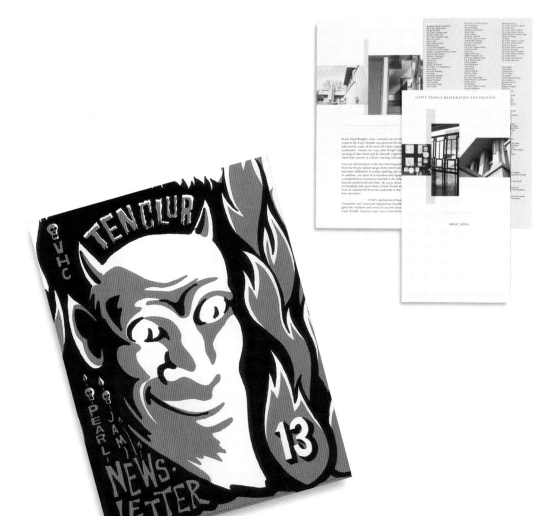

DESIGN FIRM	DESIGNERS	CLIENT	TOOLS	PAPER/MATERIAL	COLORS USED	PRINTER INFO
Ames Design	Barry Ament Cody Schultz Mark Atherton George Estrada	Pearl Jam	Ink Rubylith	Offset	Black Orange	The Copy Co.

DESIGN FIRM	ART DIRECTOR	DESIGNERS	CLIENT	TOOLS	PAPER/MATERIAL	COLORS USED	PRINTER INFO
Tom & John: A Design Collaborative	Tom Sigu	Tom Sigu John Givens Joannie Casenas	Amnesty International	QuarkXPress Adobe Photoshop	Naturalis Gallery Silk Artic White Smooth	PMS 115 Black	Stormm

DESIGN FIRM
So Design Co.

ART DIRECTOR
Olivia Swinn

DESIGNER
Aaron Pollock

CLIENT
Telecom Mobile

DESIGN FIRM	ART DIRECTOR	DESIGNER	CLIENT	TOOLS	PAPER/MATERIAL	COLORS USED	PRINTER INFO
Kolegram Design	Mike Teixeira	Mike Teixeira	Museé d'Art Urbain	QuarkXPress Adobe Photoshop Adobe Illustrator	Naturalis Gallery Silk Artic White Smooth	PMS Warm Gray 9 Black	St. Joseph Corp.

DESIGN FIRM	ART DIRECTOR	DESIGNER	CLIENT	TOOLS	COLORS USED
reddingk	Jordan Crane	Jordan Crane	Mike McGonigal	Adobe Photoshop	Cover 1: PMS 1655 / 871 Cover 2: PMS 3105 / 8643

247

DESIGN FIRM
reddingk

ART DIRECTOR
Jordan Crane

DESIGNER
Jordan Crane

CLIENT
The general public

TOOLS
Adobe Photoshop

PAPER/MATERIALS
110# Classic
 Crest
Nazdar Ink

COLORS USED
Cover 1:
PMS 299 / 390
Cover 2:
PMS 197 / 390

PRINTER INFO
Hand printed by
 Jordan Crane

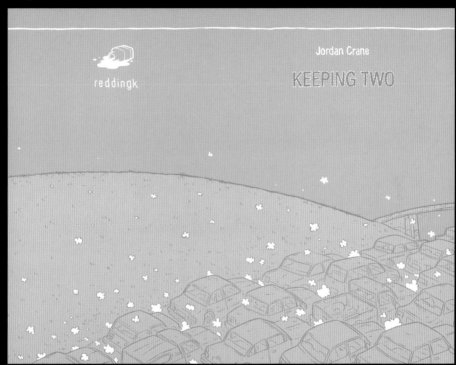

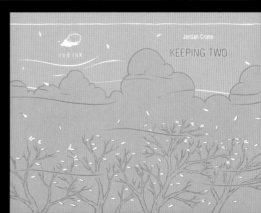

DESIGN FIRM	ART DIRECTOR	DESIGNER	CLIENT	TOOLS	PAPER/MATERIAL	COLORS USED	PRINTER INFO
Pensaré Design Group	Mary Ellen Vehlow	Amy E. Billingham	Friends of the National Arboretum	QuarkXPress	Phoenostar Dull	PMS 131 PMS 4695	Mt. Vernon Printing

DESIGN FIRM	ART DIRECTOR	DESIGNER	CLIENT	TOOLS	PAPER/MATERIALS	PRINTER INFO
Savage Design Group, Inc.	Doug Hebert	Doug Hebert	Rice Alliance for Technology and Entrepreneurship	QuarkXPress Adobe Photoshop Adobe Illustrator	French Frostone Cover French Construction Text	Signature Press

DESIGN FIRM	ART DIRECTOR	DESIGNER	CLIENT	TOOLS	PAPER/MATERIAL	COLORS USED	PRINTER INFO
Storm Visual Communications	Chantal Lancaster	Katie Rule	Cascades Fine Paper Group	QuarkXPress Adobe Photoshop	Rolland Hitech	PMS 021 Black	Lowe-Martin Group

POSTERS

posters / installations

DESIGN FIRM	DESIGNERS	CLIENT	TOOLS	PAPER/MATERIAL	COLORS USED	PRINTER INFO
Aesthetic Apparatus	Michael Byzewski Dan Ibarra	UW Student Union	Adobe Illustrator Adobe Photoshop	French paper Steel Blue	White Black	Screen Printed by Hand

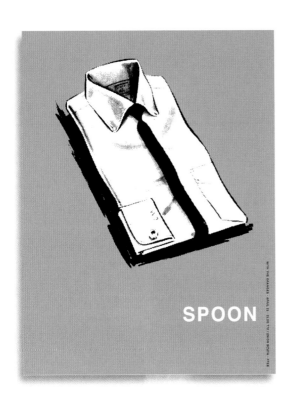

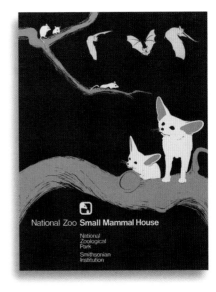

DESIGN FIRM	ART DIRECTOR	DESIGNER	CLIENT	TOOLS	PRINTER INFO
Ramona Hutko Design	Ramona Hutko	Ramona Hutko	Smithsonian Institution	Hand Illustration QuarkXPress	Silk Screened at the Smithsonian Institution

DESIGN FIRM	ART DIRECTOR	DESIGNER	CLIENT	TOOLS	COLORS USED
what!design	Damon Meibers	Derek Aylward	All Girl Skate Jam	Hand Illustration Adobe Illustrator	MATCH Brown MATCH Blue

DESIGN FIRM
Luba Lukova
Studio

ART DIRECTOR
Luba Lukova

DESIGNER
Luba Lukova

TOOLS
Tempera and
Brush

PAPER/MATERIAL
Canson

PRINTER INFO
Silk Screened by
Abart Graphics
Inc.

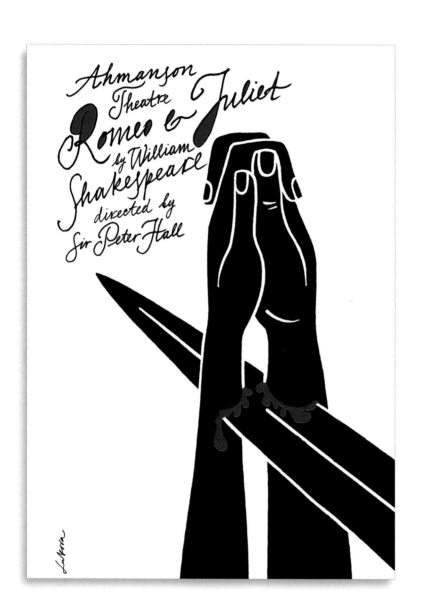

DESIGN FIRM	ART DIRECTOR	DESIGNER	TOOLS	PRINTER INFO
Did Graphics Inc.	Majid Abbasi	Majid Abbasi	Freehand Adobe Photoshop	Offset Digital

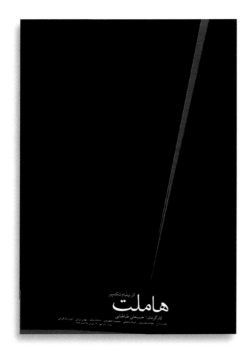

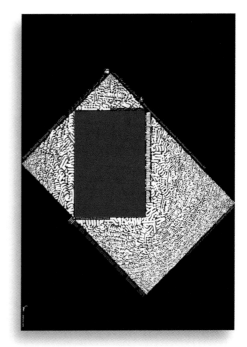

DESIGN FIRM	ART DIRECTOR	DESIGNER	CLIENT	TOOLS	PRINTER INFO
Studio Graphic Mehdi Saeedi	Mehdi Saeedi	Mehdi Saeedi	IGDS	Hand Illustration Adobe Photoshop	Ploter Print

DESIGN FIRM	ART DIRECTOR	DESIGNER	CLIENT	TOOLS	PAPER/MATERIAL	COLORS USED	PRINTER INFO
The Small Stakes	Jason Munn	Jason Munn	Q + Not U	Adobe Illustrator	French Whitewash 100# Cover	Green Black	Screen Printed by Hand Limited Run

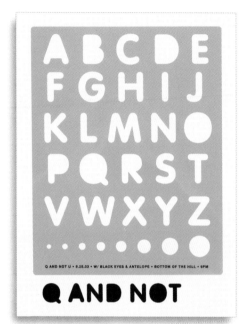

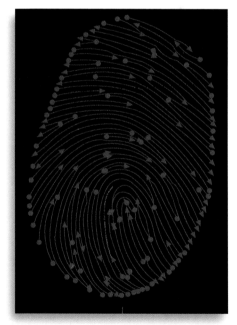

DESIGN FIRM	ART DIRECTOR	DESIGNER	CLIENT	TOOLS	PAPER/MATERIAL	COLORS USED	PRINTER INFO
Setavandyar	Pedram Harby	Pedram Harby	Setavandyar	Freehand	125g Matte Gloss paper	Red Black	Offset Print

DESIGN FIRM
Demo Design

TOOL
Adobe Illustrator

PAPER/MATERIAL
Yellow Sticker

PRINTER INFO
Screwball Press

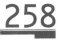
DESIGN FIRM	DESIGNER	CLIENT	PAPER/MATERIAL	COLORS USED	PRINTER INFO
Zolezzi Studio	Lourdes Zolezzi	Lourdes Zolezzi	Couche	White Black	Silk Screened

DESIGN FIRM	ART DIRECTORS	DESIGNER	CLIENT	TOOLS	PAPER/MATERIAL	COLORS USED	PRINTER INFO
Enspace, Inc.	Jenn and Ken Visocky O'Grady	Paul Perchinske	AIGA Cleveland	QuarkXPress Adobe Illustrator	Scheufelen Phoenix Motion	PMS Warm Red Black	Custom Graphics

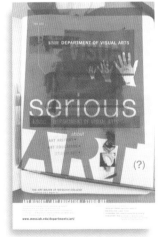

DESIGN FIRM	ART DIRECTOR	DESIGNER	CLIENT	TOOLS	COLORS USED	PRINTER INFO
Visualmentalstimuli	David Kasparek	David Kasparek	Messiah College Visual Art Department	Freehand QuarkXPress	PMS 5467 PMS 8962	Graphics Universal

DESIGN FIRM	ART DIRECTOR	DESIGNERS	CLIENT	TOOLS	PAPER/MATERIALS	PRINTER INFO
Spur Design	David Plunkert	David Plunkert Kurt Seidle Joe Parisi	Axis Theatre	QuarkXPress Adobe Illustrator Adobe Photoshop	French Duotone Butcher Off-white	Screen Printed by Spur

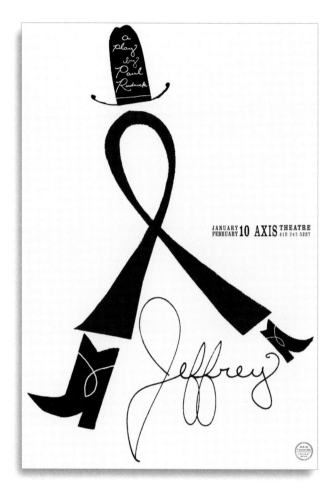

DESIGN FIRM	ART DIRECTOR	DESIGNER	CLIENT	TOOLS	PRINTER INFO
Studio Graphic Mehdi Saeedi	Mehdi Saeedi	Mehdi Saeedi	Music Festival	Hand Illustration Adobe Photoshop	Offset Print

DESIGN FIRM	ART DIRECTOR	DESIGNER	TOOLS	COLORS USED	PRINTER INFO
Grady McFerrin	Christina Auguello	Grady McFerrin	Pen and Ink Adobe Photoshop	Green Blue	Two-Color Offset

262

DESIGN FIRM	ART DIRECTOR	DESIGNER	CLIENT	TOOL	PAPER/MATERIALS	COLORS USED	PRINTER INFO
reddingk	Jordan Crane	Jordan Crane	The general public	Adobe Photoshop	110# Classic Crest Nazdar Ink	Poster 1: PMS 383 / 606 Poster 2: PMS 238 / 1225	Hand Printed by Jordan Crane

DESIGN FIRM	ART DIRECTOR	DESIGNER	CLIENT	TOOL	PAPER/MATERIALS	COLORS USED	PRINTER INFO
reddingk	Jordan Crane	Jordan Crane	The general public	Adobe Photoshop	110# Classic Crest Nazdar Ink	Poster 3: PMS 4635 / 124 Poster 4: PMS 3015 / 310	Hand Printed by Jordan Crane

DESIGN FIRM	ART DIRECTORS	DESIGNERS	CLIENT	TOOLS	PAPER/MATERIAL	COLORS USED
BC Design	Mike Calkins David Bates	Mike Calkins David Bates	Pyramid Breweries	Freehand	Newsprint	Poster 1: PMS 1245 / 294

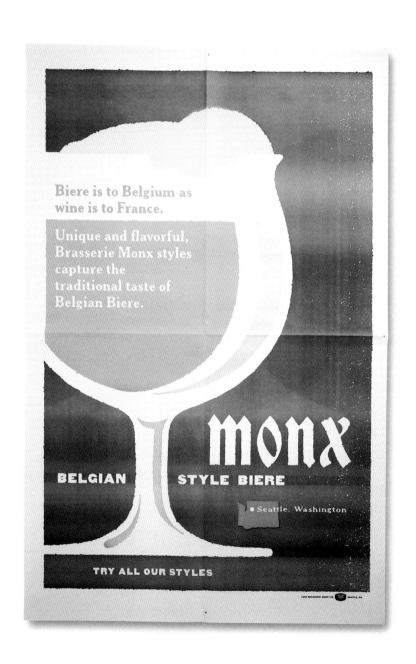

DESIGN FIRM	ART DIRECTORS	DESIGNERS	CLIENT	TOOLS	PAPER/MATERIAL	COLORS USED
BC Design	Mike Calkins David Bates	Mike Calkins David Bates	Pyramid Breweries	Freehand	Newsprint	Poster 2: PMS 1245 / 1525 Poster 3: PMS 1245 / 341 Poster 4: PMS 1245 / 147

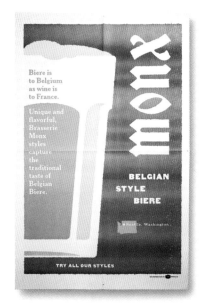

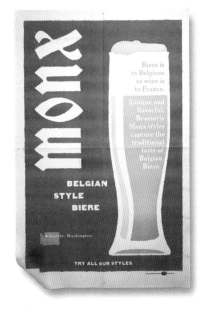

DESIGN FIRM	ART DIRECTOR	DESIGNER	CLIENT	TOOLS	PAPER/MATERIAL	COLORS USED	PRINTER INFO
Modern Dog	Mike Strassburger	Mike Strassburger	House of Blues	Adobe Illustrator Adobe Photoshop	80# Cover Cougar Opaque	PMS 1375 Black	Clone Press

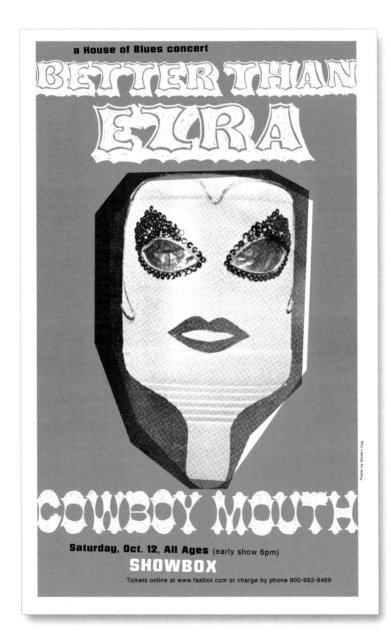

DESIGN FIRM	DESIGNER	CLIENT	TOOLS	PAPER/MATERIAL	COLORS USED	PRINTER INFO
Grady McFerrin	Grady McFerrin	Grady McFerrin	Pen and Ink Adobe Photoshop	Rives BFK	PMS 577 PMS 141	The Mechanical San Francisco

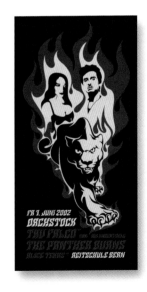

DESIGN FIRM	ART DIRECTOR	DESIGNER	CLIENT	TOOLS	PAPER/MATERIAL	PRINTER INFO
Hausgrafik	Urs Althaus	Urs Althaus	Reitschule Dachstock Bern	Pismo	170g Offset Paper	Basis Druck Bern

268

ART DIRECTOR	DESIGNER	TOOL	PAPER/MATERIAL	COLORS USED	PRINTER INFO
Michael Bartalos	Michael Bartalos	Adobe Illustrator Hand Illustration	French Dur-o-tone Newsprint White 80# Cover	Warm Red Process Blue	Letterpress by Chadwick Johnson

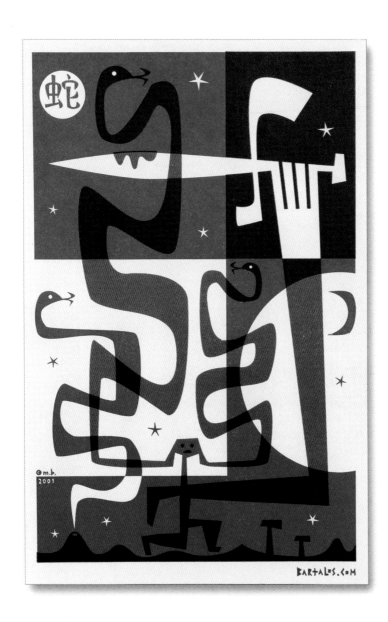

DESIGN FIRM	DESIGNERS	CLIENT	TOOLS	PAPER/MATERIAL	COLORS USED	PRINTER INFO
Aesthetic Apparatus	Michael Byzewski Dan Ibarra	First Avenue	Adobe Illustrator Adobe Photoshop	French Paper Cement Green	Pink Black	Screen Printed by Hand

DESIGN FIRM
Design Machine

ART DIRECTOR
A. Gelman

DESIGNER
A. Gelman

CLIENT
Design News
Tokyo

TOOL
Adobe Illustrator

Subtraction lessons by
Alexander Gelman
Lesson three: Balance

The notion of balance has
always been at the core of the
human search for perfect
composition. Various cultures
and historical periods
developed their own formulas for
perfect proportions and harmony.
When considering these recipes,
try this easy simple exercise.

1. Take a glass of water and place
it in the middle of a table.
A glass of water by itself
doesn't generate much interest.
It is an ordinary safe and
ordinary, safe and balanced
environment.

2. Move the glass so that it is
half-way off the edge of the table.
This time the glass is likely to
be noticed and someone may even be
tempted to move it back toward the
center of the table.

3. Now, push the glass further off
the table. The balance is lost. The
glass falls, the water spills. The
energy is released.

The focus of Subtraction is the very
moment when the equilibrium is about
to be lost, when everything is about
to fall apart, yet it is still
balanced and contained.

This fragile state between balance and
imbalance creates the optimum tension.
It radiates energy and provokes a
response.

バランスという概念は、つねに人間による完璧な構図（コンポジション）
を追い求める核となってきた。様々な文化や時代は完璧なプロポーションや調和の
ための独自の公式を構築してきた。これらのレシピを考慮する時、
以下のシンプルな方法を試してみよう。

1. グラス一杯の水を用意し、それをテーブルの中央に置く。グラス一杯のその水自体
はたいした興味を引くものではないが、それは普通で安全なバランスのとれた状況に置か
れた普通の物体であるからである。

2. 今度テーブルの端からはみ出るようにグラスを移動する。すると、そのグラスは
注目されやすく、人によってはそれをテーブルの中央の方へ戻そうという誘惑に駆られる
かもしれない。

3. 今度はそのグラスをさらにテーブルの外へ押し出す。バランスが崩れてグラスが落ち、
水がこぼれる。エネルギーが放出されたのである。

サブトラクションの焦点は不安定さがまさに失われようとする瞬間、すべてが崩れ去ろうとする瞬間、
しかしそれでもそれがそのままグラスが入るまで。どうにかまとまっている状態である。

このバランスとアンバランスの間（はざま）にある壊れやすい状態が最適のテンションを生み、
エネルギーを放射、次の反応を誘発させるのである。

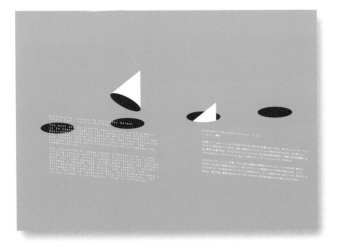

DESIGN FIRM	ART DIRECTOR	DESIGNER	CLIENT	TOOLS	PAPER/MATERIAL	COLORS USED	PRINTER INFO
Modern Dog	Junichi Tsuneoka	Junichi Tsuneoka	House of Blues	Adobe Illustrator	Cover 80#	PMS 1375	Clone Press
				Adobe Photoshop	Cougar Opaque	PMS 1815	

VOLANTE : REMIXES CD RELEASE SHOW • WITH DOSH AND KID VENGEANCE

FRIDAY NOV 29, THE 7TH STREET ENTRY - 2 SHOWS: 5PM ALL AGES, 9PM 21+ ID

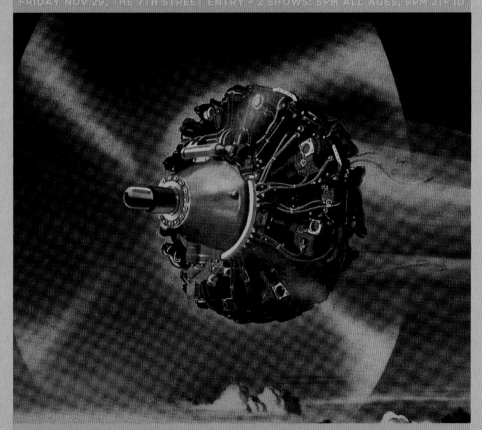

$4 ADVANCE TICKETS AVAILABLE AT ALL TICKET OUTLETS, $6 DOOR ⟫ VOLANTE HOTLINE 612.272.7289 • WWW.VOLANTE.NET

DESIGN FIRM	DESIGNERS	CLIENT	TOOLS	PAPER/MATERIAL	COLORS USED	PRINTER INFO
Aesthetic Apparatus	Dan Ibarra Michael Byzewski	7th St. Entry	Adobe Illustrator Adobe Photoshop	French Paper Whitewash	Pink Blue	Screen Printed by Hand

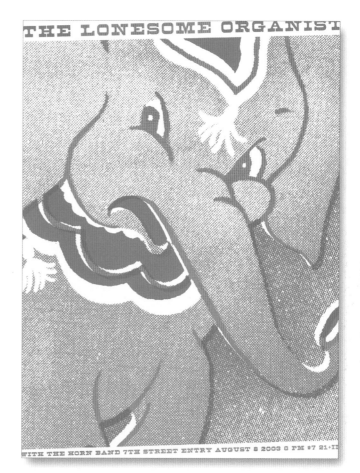

DESIGN FIRM	ART DIRECTOR	DESIGNER	CLIENT	TOOLS	PAPER/MATERIAL	COLORS USED	PRINTER INFO
WPA Pinfold	James Littlewood	Stuart Morey	Sheffield Theatres	QuarkXPress Macintosh	Lumi Art	Black Rhodamine Red	The Production Company

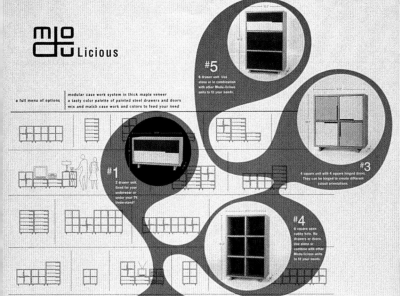

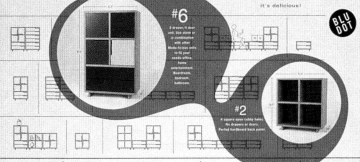

modu Licious

a full menu of options | modular case work system in thick maple veneer
a tasty color palette of painted steel drawers and doors
mix and match case work and colors to feed your need

#5
6 drawer unit. Use alone or in combination with other Modu-licious units to fit your needs.

#1
2 drawer unit. Good for your underwear or under your TV. Understand?

#3
4 square unit with 4 square hinged doors. They can be hinged to create different cutout orientations.

#4
6 square open cubby hole. No drawers or doors. Use alone or combine with other Modu-licious units to fit your needs.

mouth-watering solutions for your storage needs. select modu-licious units to create your own combo platter.

it's delicious!

BLU DOT

#6
2 drawer/4 door unit. Use alone or in combination with other Modu-licious units to fit your needs-office, home entertainment, boardroom, bedroom, bathroom.

#2
4 square open cubby holes. No drawers or doors. Perfed hardboard back panel.

colors	white	flw red⁻	gray blue	steel powder coated drawers and doors	BLU DOT
	off-white	sage green	slate	1" thick maple veneer cabinets	1500 JACKSON ST. N.E.
				perforated hardboard back panels	MPLS. MN 55413

TEL 612 782 1844
FAX 612 782 1845
WEB www.bludot.com

DESIGN FIRM	DESIGNERS	CLIENT	TOOLS	PAPER/MATERIAL	COLORS USED	PRINTER INFO
Aesthetic Apparatus	Dan Ibarra Michael Byzewski	American Poster Institute	Adobe Illustrator Adobe Photoshop	French Paper Steel Blue	Cyan White	Screen Printed by Hand

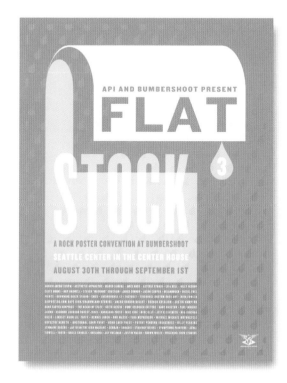

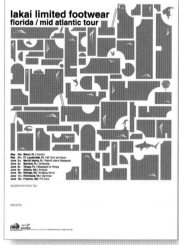

DESIGN FIRM	ART DIRECTOR	DESIGNER	CLIENT	TOOLS
The Art Dump/ Ohio Girl Design	Andy Mueller	Andy Mueller	Lakai Limited Footwear	Adobe Illustrator

DESIGN FIRM	ART DIRECTOR	DESIGNER	CLIENT	TOOL	PAPER/MATERIAL	COLORS USED	PRINTER INFO
WPA Pinfold	James Littlewood	Stuart Morey	Sheffield Theatres	QuarkXPress	Lumi Art	PMS 201 Black	The Production Company

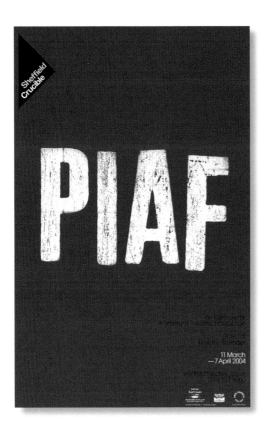

DESIGN FIRM	ART DIRECTOR	DESIGNER	TOOLS	PRINTER INFO
Did Graphics Inc.	Majid Abbasi	Majid Abbasi	Freehand Adobe Photoshop	Offset Digital

DESIGN FIRM	ART DIRECTOR	DESIGNER	CLIENT	TOOL	PAPER/MATERIAL	COLORS USED	PRINTER INFO
The Small Stakes	Jason Munn	Jason Munn	The American Analog Set	Adobe Illustrator	100# Cover French Paper Whitewash	Lavender Black	Screen Printed by Hand Limited run

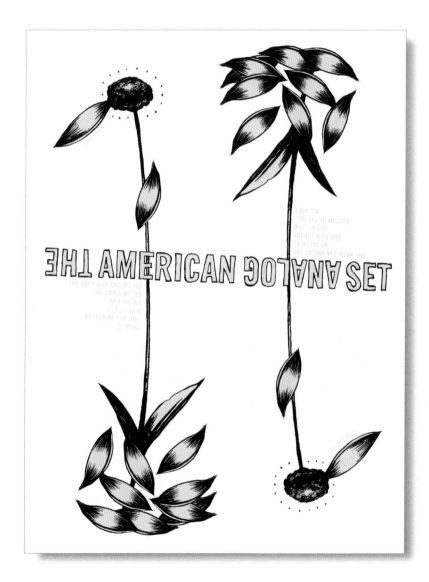

DESIGN FIRM	DESIGNERS	CLIENT	TOOLS	PAPER/MATERIAL	COLORS USED	PRINTER INFO
Aesthetic Apparatus	Michael Byzewski Dan Ibarra	O'Cayz Corral	Adobe Illustrator Adobe Photoshop	French Paper Frostbite	Red Black	Screen Printed by Hand

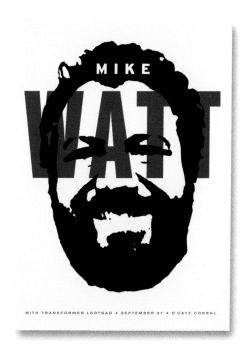

DESIGN FIRM	ART DIRECTOR	DESIGNER	CLIENT	TOOLS	COLORS USED	PRINTER INFO
Hybrid Design	Brian Flynn	Brian Flynn	Nike, Inc.	Adobe Illustrator Adobe Photoshop	PMS 382 Black	Formit

DESIGN FIRM	ART DIRECTOR	DESIGNER	CLIENT	TOOL	PAPER/MATERIAL	PRINTER INFO
Hausgrafik	Urs Althaus	Urs Althaus	ISC Club Bern	Pismo	170g Offset Paper	Basis Druck Bern

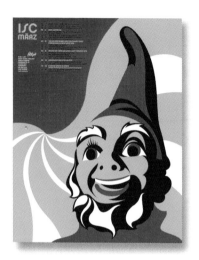

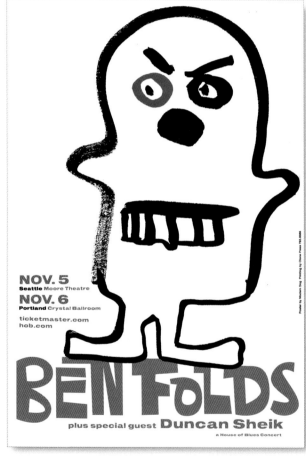

DESIGN FIRM	ART DIRECTOR	DESIGNER	CLIENT	TOOL	PAPER/MATERIAL	COLORS USED	PRINTER INFO
Modern Dog	Robynne Raye	Robynne Raye	House of Blues	Adobe Illustrator	Cougar Opaque Cover 80#	PMS 211 Black	Clone Press

DESIGN FIRM	DESIGNER	CLIENT	TOOL	PAPER/MATERIAL	COLORS USED	PRINTER INFO
The Heads of State	Dustin Summers	Aero Booking	Adobe Photoshop	Wausau Royal Silk White	Maroon Powder Blue	Largemammal Prints

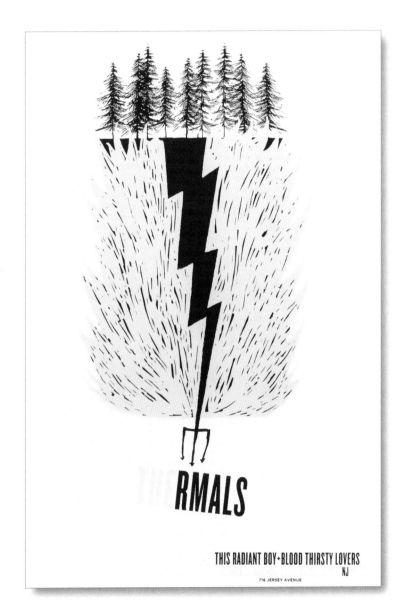

DESIGN FIRM
Luba Lukova
 Studio

ART DIRECTOR
Luba Lukova

DESIGNER
Luba Lukova

TOOLS
Tempera
 and Brush

PAPER/MATERIAL
Canson

PRINTER INFO
Silk Screened by
 Abart Graphics
 Inc.

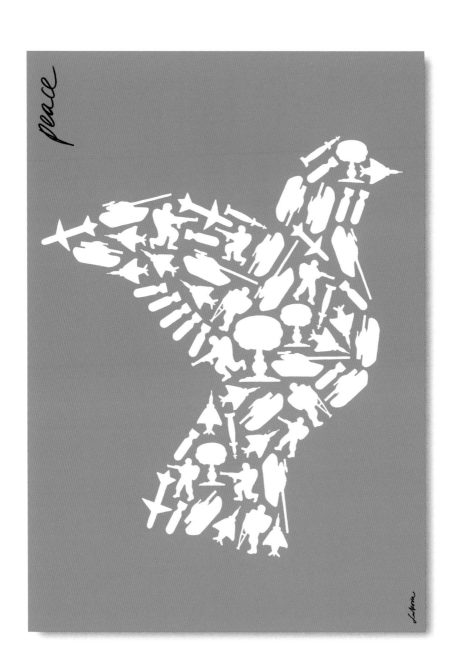

DESIGN FIRM	ART DIRECTOR	DESIGNER	CLIENT	TOOLS	PAPER/MATERIAL	COLORS USED	PRINTER INFO
The Small Stakes	Jason Munn	Jason Munn	The Ramp	Adobe Illustrator	100# Cover French Paper Whitewash	Orange Black	Screen Printed by Hand Limited Run

DESIGN FIRM
Nike Brand Design

DESIGNER
Heather
Amuny-Dey

CLIENT
Nike, Inc.

TOOL
Adobe Illustrator

PAPER/MATERIAL
McCoy Velvet

PRINTER INFO
Dynagraphics

The case
for stairs.

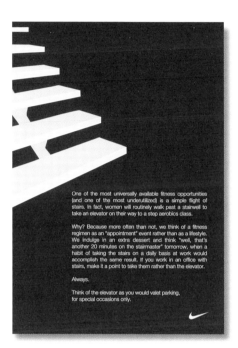

One of the most universally available fitness opportunities (and one of the most underutilized) is a simple flight of stairs. In fact, women will routinely walk past a stairwell to take an elevator on their way to a step aerobics class.

Why? Because more often than not, we think of a fitness regimen as an "appointment" event rather than as a lifestyle. We indulge in an extra dessert and think "well, that's another 20 minutes on the stairmaster" tomorrow, when a habit of taking the stairs on a daily basis at work would accomplish the same result. If you work in an office with stairs, make it a point to take them rather than the elevator.

Always.

Think of the elevator as you would valet parking, for special occasions only.

DESIGN FIRM
Chen Design
 Associates

ART DIRECTOR
Joshua C. Chen

DESIGNER
Max Spector

CLIENT
"Quality of Life"

TOOLS
Adobe Photoshop
QuarkXPress

COLORS USED
PMS 5787
PMS 1245

PRINTER INFO
Olympic Screen
 Graphics

DESIGN FIRM	ART DIRECTOR	DESIGNERS	CLIENT	TOOLS	PAPER/MATERIAL	COLORS USED	PRINTER INFO
50,000 Feet, Inc.	Michael Petersen	Michael Petersen Ken Fox	Harley-Davidson Motor Co.	QuarkXPress Adobe Photoshop	65# Cover Domtar Titanium Opaque	PMS 121 PMS 725	The Hennegan Company

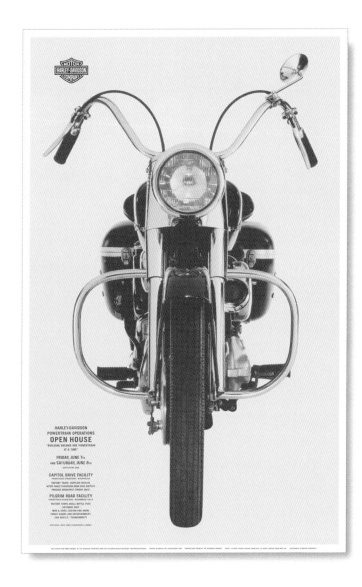

DESIGN FIRM	ART DIRECTOR	DESIGNER	TOOLS	PRINTER INFO
Did Graphics Inc.	Majid Abbasi	Majid Abbasi	Adobe Photoshop Freehand	Offset Digital

DESIGN FIRM	ART DIRECTOR	DESIGNER	TOOLS	PRINTER INFO
Did Graphics Inc.	Majid Abbasi	Majid Abbasi	Adobe Photoshop Freehand	Offset Digital

DESIGN FIRM	ART DIRECTOR	DESIGNER	CLIENT	TOOL	PAPER/MATERIALS	COLORS USED	PRINTER INFO
Stim Visual Communication	Timothy Samara	Timothy Samara	AIGA Upstate New York	QuarkXPress	Ultra 80# Text Mead Sterling Ultra	PMS 021 PMS 623	Eastwood Litho

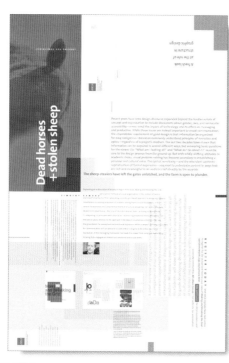

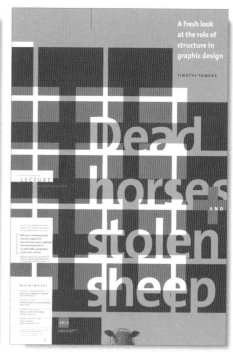

DESIGN FIRM	ART DIRECTOR	DESIGNERS	CLIENT	TOOL	PAPER/MATERIAL	COLORS USED	PRINTER INFO
Niklaus Troxler Design	Niklaus Troxler	Erich Brechbuhl Niklaus Troxler	Pharmacist Association, Lucerne	Adobe Photoshop	Poster Paper	Blue Green	Silk Screened

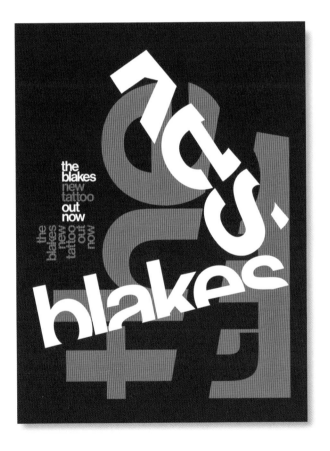

DESIGN FIRM	ART DIRECTOR	DESIGNER	CLIENT	TOOL	PAPER/MATERIAL	COLORS USED	PRINTER INFO
Stereotype Design	Mike Joyce	Mike Joyce	The Blakes	Adobe Illustrator	French	Magenta Maroon	Lucky Bunny

DESIGN FIRM
Ames Design

DESIGNER
Coby Schultz

CLIENT
Pearl Jam

TOOLS
Pen and Ink
Adobe Illustrator

COLORS USED
Dark Blue
Red

PRINTER INFO
Patent Pending

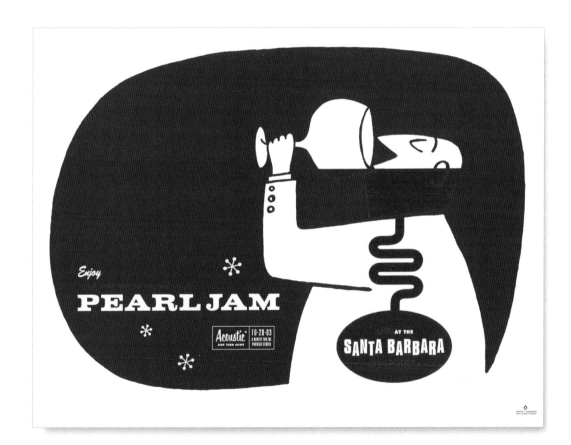

DESIGN FIRM	ART DIRECTOR	DESIGNERS	CLIENT	COLORS USED	PRINTER INFO
Werner Design Werks	Sharon Werner	Sharon Werner Sarah Nelson	University of Minnesota Department of Cultural Studies	Brown / Blue 4-color Tearoffs	University of Minnesota Printing Services

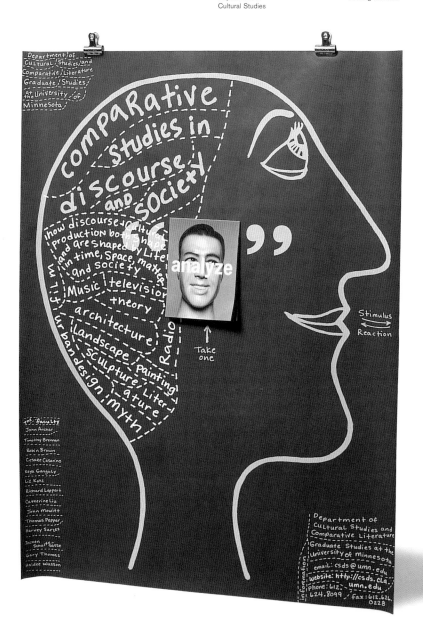

DESIGN FIRM	ART DIRECTOR	DESIGNER	CLIENT	TOOLS	PAPER/MATERIAL	COLORS USED	PRINTER INFO
Spur Design	David Plunkert	David Plunkert	Turn Around	Adobe Photoshop QuarkXPress	Curtis Tweed Weave	PMS 166 Black	London Litho

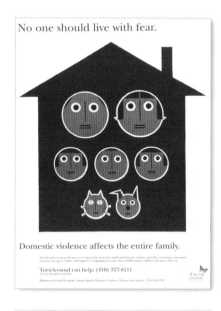

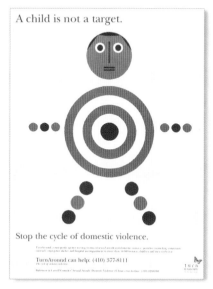

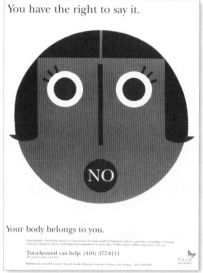

PACKAGING AND PRODUCT GRAPHICS

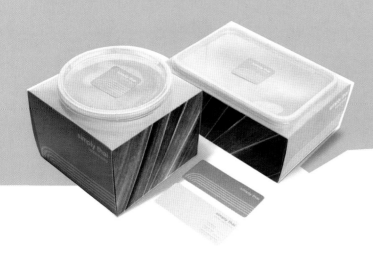

packaging / tags / CDs / wrapping paper / bags / t-shirts

DESIGN FIRM	ART DIRECTOR	DESIGNER	CLIENT	TOOL	PAPER/MATERIALS	COLORS USED	PRINTER INFO
Sandstrom Design	Steve Sandstrom	Steve Sandstrom	Pavlov Productions	Adobe Illustrator	Fox River Quest Putty Chip Board	PMS 9160 Black	Offset printing Lamination Rubber stamping

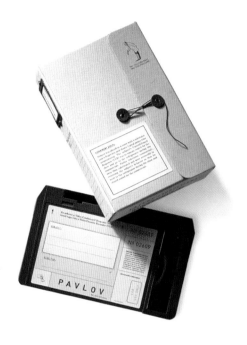

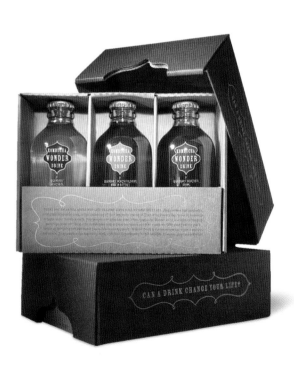

DESIGN FIRM	ART DIRECTOR	DESIGNER	CLIENT	TOOL	PAPER/MATERIAL	COLORS USED	PRINTER INFO
Sandstrom Design	Michele Melandri	Steve Sandstrom	Kombucha Wonder Drink	Adobe Illustrator	Kraft	Red Silver	The Box Maker

DESIGN FIRM	ART DIRECTORS	DESIGNER	CLIENT	TOOL	COLORS USED	PRINTER INFO
Sandstrom Design	Steve Sandstrom Starlee Matz	Starlee Matz	Pacifica Natural Skin Care	Adobe Illustrator	1 PMS Color Black	The Irwin-Hodson Company

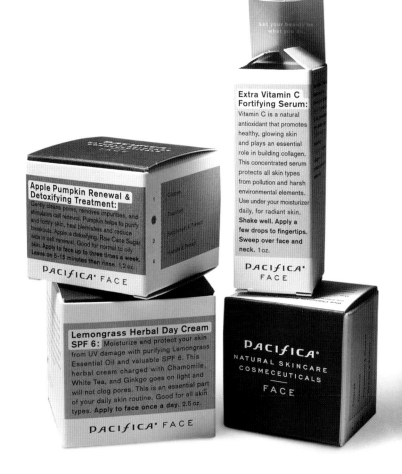

Extra Vitamin C Fortifying Serum: Vitamin C is a natural antioxidant that promotes healthy, glowing skin and plays an essential role in building collagen. This concentrated serum protects all skin types from pollution and harsh environmental elements. Use under your moisturizer daily, for radiant skin. **Shake well. Apply a few drops to fingertips. Sweep over face and neck.** 1oz.

PACIFICA· FACE

Apple Pumpkin Renewal & Detoxifying Treatment: Gently cleans pores, removes impurities, and stimulates cell renewal. Pumpkin helps to purify and fortify skin, heal blemishes and reduce breakouts. Apple is detoxifying. Raw Cane Sugar aids in cell renewal. Good for normal to oily skin. Apply to face up to three times a week. Leave on 5-15 minutes then rinse. 1.2 oz.

PACIFICA· FACE

Lemongrass Herbal Day Cream SPF 6: Moisturize and protect your skin from UV damage with purifying Lemongrass Essential Oil and valuable SPF 6. This herbal cream charged with Chamomile, White Tea, and Ginkgo goes on light and will not clog pores. This is an essential part of your daily skin routine. Good for all types. **Apply to face once a day.** 2.5 oz.

PACIFICA· FACE

PACIFICA·
NATURAL SKINCARE
COSMECEUTICALS
——
FACE

DESIGN FIRM	ART DIRECTOR	DESIGNER	CLIENT	TOOL	PAPER/MATERIALS	COLORS USED
General Public Inc.	General Public Inc.	General Public Inc.	The Gap	Freehand	Cardboard box Records	Silver Foil Black

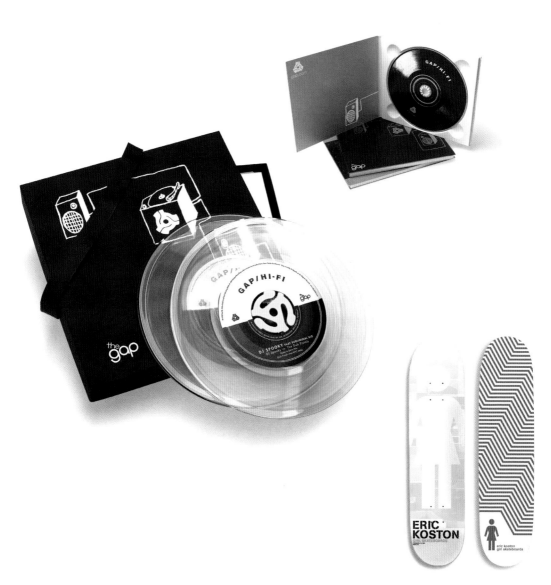

DESIGN FIRM	ART DIRECTOR	DESIGNER	CLIENT	TOOLS	PAPER/MATERIAL
The Art Dump/ Ohio Girl Design	Andy Mueller	Andy Mueller	Girl Skateboards	Adobe Illustrator Adobe Photoshop	Naturalis Gallery Silk Artic White Smooth

DESIGN FIRM	TOOL	PAPER/MATERIAL	PRINTER INFO
General Public Inc.	Freehand	Topsheet Laminate Material	Silk Screened

DESIGN FIRM	ART DIRECTORS	DESIGNER	CLIENT	TOOL	PAPER/MATERIAL	COLORS USED
BC Design	Mike Calkins David Bates	Pat Snavely	Turner Classic Movies	Freehand	Cotton T-shirt	PMS 294 PMS 200

DESIGN FIRM	ART DIRECTOR	DESIGNER	CLIENT	TOOLS	PAPER/MATERIAL	COLORS USED	PRINTER INFO
Jason Schulte Design	Jason Schulte	Jason Schulte	JLine–Jewelry Designer	Adobe Illustrator Adobe Photoshop QuarkXPress	Naturalis Gallery Silk Artic White Smooth	PMS 291 PMS 295	Offset

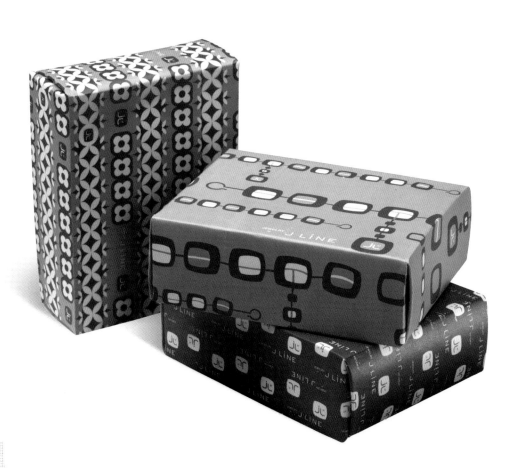

DESIGN FIRM	ART DIRECTORS	DESIGNER	CLIENT	TOOL	PAPER/MATERIAL	COLORS USED
BC Design	Mike Calkins David Bates	Ryan Jacobs	Turner Classic Movies	Freehand	80# Cover	PMS Metallic 8400 Black

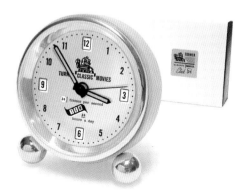

DESIGN FIRM	ART DIRECTORS	DESIGNER	CLIENT	COLORS USED
BC Design	Mike Calkins David Bates	Mike Calkins	Bugle Boy	PMS 5445 PMS 123

DESIGN FIRM	ART DIRECTOR	DESIGNER	CLIENT	TOOLS	COLORS USED
Strichpunkt GmbH	Kirsten Dietz	Felix Widtiaier	Christoph Soldan	Adobe Illustrator	PMS 295
				QuarkXPress	PMS 872

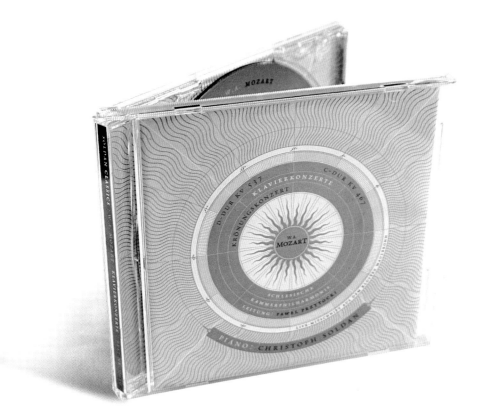

DESIGN FIRM	ART DIRECTOR	DESIGNER	CLIENT	TOOLS	PAPER/MATERIAL	COLORS USED	PRINTER INFO
Kevin Clarke Design	Kevin Clarke	Kevin Clarke	The Cubby Creatures	Adobe Illustrator Adobe Photoshop	Silk Screened	Metallic Blue Metallic Brown	Silk Screened By The Band

DESIGN FIRM	ART DIRECTOR	DESIGNERS	CLIENT	TOOLS	PAPER/MATERIAL	COLORS USED	PRINTER INFO
Sandstrom Design	Steve Sandstrom	Steve Sandstrom Greg Parra	Kink fm102	Adobe Illustrator	CIS Board Stock	PMS 550 Black	Sony Disc Manufacturing

DESIGN FIRM
Duffy
Singapore

ART DIRECTOR
Christopher Lee

DESIGNER
Cara Ang

CLIENT
Simply Thai

TOOL
Freehand

PAPER/MATERIAL
Foodboard with
Matte Varnish

COLORS USED
PMS 3975
Black

PRINTER INFO
G-Pack.com
Pte Ltd

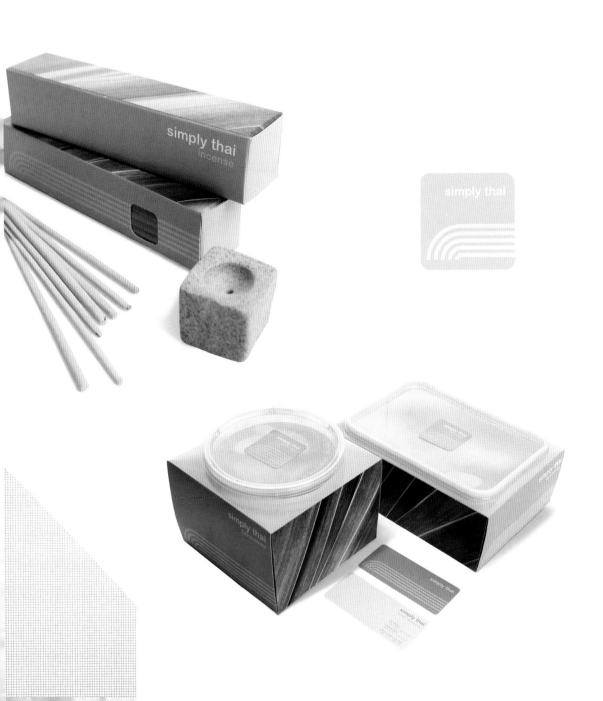

DESIGN FIRM	ART DIRECTOR	DESIGNER	CLIENT	TOOLS
The Art Dump/ Ohio Girl Design	Andy Mueller	Andy Mueller	Lakai Limited Footwear	Adobe Illustrator

DESIGN FIRM	ART DIRECTOR	DESIGNER	CLIENT	TOOLS	PAPER/MATERIALS	COLORS USED
Hybrid Design	Brian Flynn	Brian Flynn	Allies of the R:Evolution	Adobe Illustrator Adobe Photoshop	Felt Pennants Vinyl Stickers Pins	PMS 166 PMS 4625

DESIGN FIRM	ART DIRECTOR	DESIGNER	CLIENT	TOOL	PAPER/MATERIAL	COLORS USED
BC Design	Mike Calkins	Ryan Jacobs	Blue Q	Freehand	Recycled Posterboard	PMS 173 PMS 072

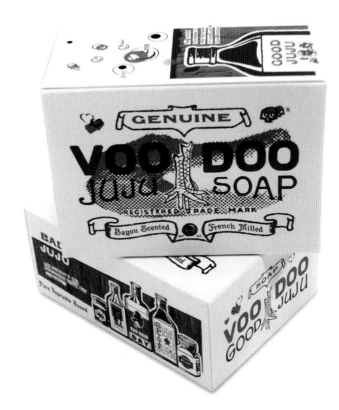

DESIGN FIRM	ART DIRECTOR	DESIGNER	CLIENT	TOOL	PAPER/MATERIAL	COLORS USED	PRINTER INFO
Gardner Design	Brian Miller	Luke Bott	Standard	Freehand	Cougar	PMS 337 PMS 4975	Printmaster

DESIGN FIRM	ART DIRECTOR	DESIGNER	CLIENT	TOOL	PAPER/MATERIAL	COLORS USED
BC Design	Mike Calkins	Ryan Jacobs	Mecca	Freehand	Cotton T-shirt	Shirt 1: White / PMS 2748 Shirt 2: PMS 201 / PMS Cool Gray 5

DESIGN FIRM	ART DIRECTOR	DESIGNER	CLIENT	TOOLS	PAPER/MATERIALS	COLORS USED	PRINTER INFO
Duffy New York	Alan Colvin	David Mashburn	Fractal, LLC	Adobe Illustrator	Fox River Paper Starwhite 70# text, Tiara color	PMS 116 PMS 168	InterLect Color

DESIGN FIRM
Duffy
 Minneapolis

ART DIRECTORS
Kobe Suvongse
Alan Colvin

DESIGNERS
Joe Monnens
Paulina Reyes
Carol Richards

CLIENT
Façonnable

TOOL
Adobe Illustrator

COLORS USED
PMS 1665
PMS 534

INVITES AND
ANNOUNCEMENTS

brochures / flyers / cards

DESIGN FIRM	ART DIRECTOR	DESIGNER	CLIENT	PAPER/MATERIAL	COLORS USED	PRINTER INFO
Jason Schulte Design	Jason Schulte	Jason Schulte	Jason Schulte Design	French Construction Pure White	PMS Yellow PMS 2975	Studio on Fire

DESIGN FIRM	ART DIRECTOR	DESIGNER	CLIENT	TOOL	PAPER/MATERIAL	COLORS USED	PRINTER INFO
BBK Studio	Sharon Oleniczak	Brian Hauch	GVSU	QuarkXPress	Nasau Astropaque	PMS 165 / 223 PMS 376 / 165 PMS 223 / 376	Foremost Graphics

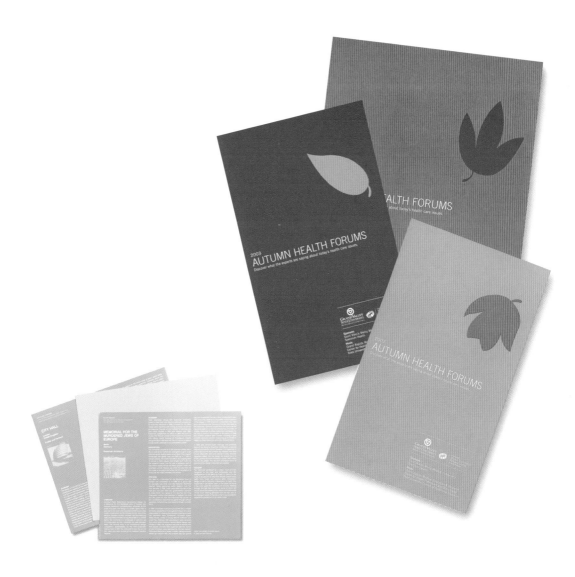

DESIGN FIRM	ART DIRECTORS	CLIENT	TOOL	PAPER/MATERIAL	COLORS USED	PRINTER INFO
Flat	Petter Ringbom Tsia Carson Doug Lloyd	Van Alen Institute	Adobe InDesign	100# Dull Coat Text	PMS 381 PMS 326	Soho Reprographics

DESIGN FIRM	ART DIRECTOR	DESIGNER	CLIENT	TOOLS	PAPER/MATERIAL	COLORS USED	PRINTER INFO
what!design	Damon Meibers	Damon Meibers	Gotham Chamber Opera	QuarkXPress Adobe Photoshop	Finch Opaque Vanilla 80# Text	PMS 202 PMS 144	Stuart Litho

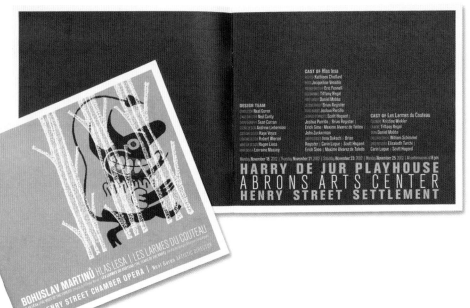

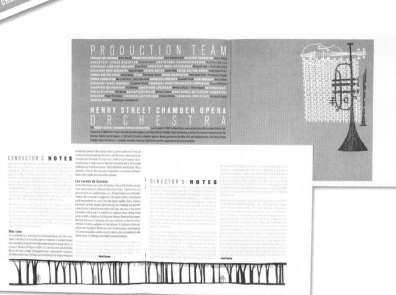

DESIGN FIRM	ART DIRECTOR	DESIGNER	CLIENT	TOOL	PAPER/MATERIAL	COLORS USED	PRINTER INFO
Blue River	Lisa Thundercliffe	Lisa Thundercliffe	Durham City Arts	QuarkXPress	170g Regency Silk	PMS 137 PMS 8543	Billingham Press

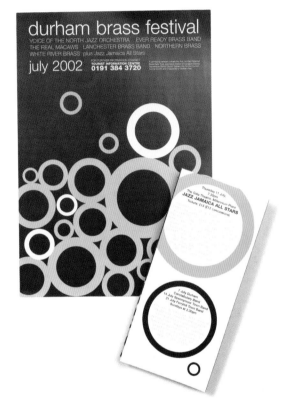

DESIGN FIRM	DESIGNER	CLIENT	TOOL	COLORS USED	PRINTER INFO
Methodologie	Leo Raymundo	William Traver Gallery	QuarkXPress	PMS 469 Process Blue	The Copy Company

DESIGN FIRM	DESIGNER	CLIENT	TOOL	COLORS USED	PRINTER INFO
Methodologie	Minh Nguyen	Tenzing	QuarkXPress	PMS 1375 Black	Forward Press

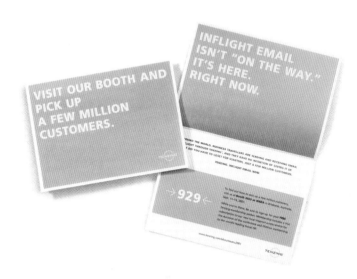

DESIGN FIRM	ART DIRECTOR	DESIGNER	TOOL	PAPER/MATERIAL	PRINTER INFO
Manifesto Press	Bryan Hutcheson	Bryan Hutcheson	Adobe Illustrator	Strathmore 38# Cover	Manifesto Press

315

DESIGN FIRM	ART DIRECTOR	DESIGNERS	CLIENT	TOOLS	PAPER/MATERIALS	COLORS USED	PRINTER INFO
Spur Design	David Plunkert	David Plunkert Kurt Seidle	Mercy Medical Center	Adobe Illustrator QuarkXPress	Cougar Cougar Natural	PMS 289 PMS 606	Advance

DESIGN FIRM	ART DIRECTOR	DESIGNER	CLIENT	COLORS USED	PRINTER INFO
So Design Co.	Aaron Pollock	Aaron Pollock	Unit 1	Black Hexachrome Orange	Shapco Printing

DESIGN FIRM	ART DIRECTOR	DESIGNERS	CLIENT	COLORS USED
Werner Design Werks	Sharon Werner	Sharon Werner Sarah Nelson	University of Minnesota	Black Red

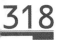

DESIGN FIRM	ART DIRECTOR	DESIGNER	CLIENT	PAPER/MATERIAL	COLORS USED	PRINTER INFO
BC Design	David Bates	David Bates	BC Design	Fabriano	PMS 578 PMS 175	Athenaeum Press

Cards are for giving.
Friends are forgiving.

Choose 5.

Happy Holidays from all of us at BC Design.

bcdesign.com

DESIGN FIRM	ART DIRECTOR	DESIGNER	CLIENT	TOOLS	PAPER/MATERIALS	COLORS USED	PRINTER INFO
Sussner Design	Derek Sussner	Brent Gale	ASMP (American Society of Media Photographers)	Adobe Photoshop Adobe Illustrator	Fox River Sundance Smoke 80# Text	Black Metallic Blue	Flaire Print Communications

DESIGN FIRM	ART DIRECTORS	DESIGNERS	CLIENT	TOOLS	PAPER/MATERIALS	COLORS USED	PRINTER INFO
Hornall Anderson Design Works	Kris Delaney Sonja Max Henry Yiu	Beth Clawson Mike Joosse Jenny Harrington Scott Rier Kate Kroener	Hornall Anderson Design Works	Freehand Adobe Photoshop	60# Pacesetter Matte Book	Poster 1: PMS 021 / 877 Poster 2: PMS 646 / 877	G.A.C. Seattle

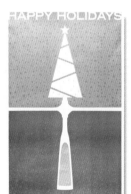

DESIGN FIRM	ART DIRECTOR	DESIGNER	TOOLS	PAPER/MATERIAL	COLORS USED	PRINTER INFO
Grady McFerrin	Grady McFerrin	Grady McFerrin	Pen and ink Adobe Photoshop	Fabriano Medioevalis	Light Blue Brown	The Mechanical

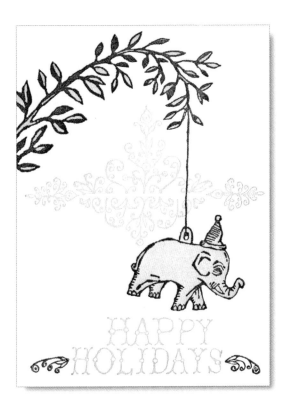

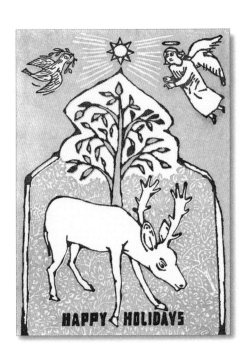

DESIGN FIRM	ART DIRECTOR	DESIGNER	TOOLS	PAPER/MATERIAL	COLORS USED	PRINTER INFO
gmillustration.com	Grady McFerrin	Grady McFerrin	Pen and ink Adobe Photoshop	Rives BFK	Pink Maroon	The Mechanical

DESIGN FIRM DESIGNER CLIENT TOOLS PAPER/MATERIAL COLORS USED PRINTER INFO

Grady McFerrin Grady McFerrin Rhys Levenson Pen and Ink Fabriano Pink The Mechanical
 Tim Mason Adobe Photoshop Medioevalis Brown

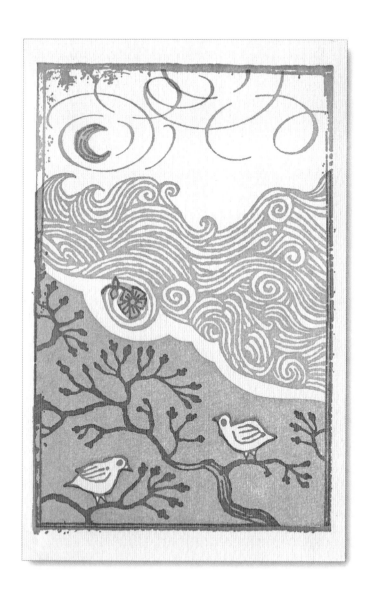

DESIGN FIRM	ART DIRECTORS	DESIGNERS	CLIENT	TOOLS	PAPER/MATERIAL	COLORS USED	PRINTER INFO
Cronk Shepard Design	Wendy Cronk Gullivar Shepard	Wendy Cronk Gullivar Shepard	Wendy Cronk Gullivar Shepard	Adobe Photoshop Adobe Illustrator	Cranes 134# Pearl White	PMS Black PMS 5493	Letterpress

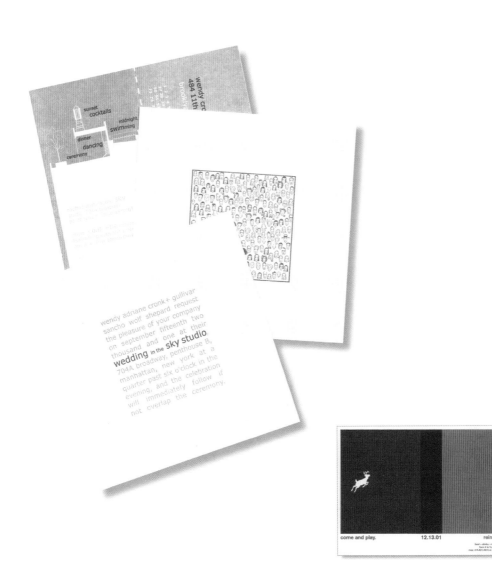

DESIGN FIRM	DESIGNER	CLIENT	TOOL	COLORS USED	PRINTER INFO
Cahan & Associates	Gary Williams	Cahan & Associates	Adobe Illustrator	Orange Rhodamine Red	Nat Swope

DESIGN FIRM	ART DIRECTOR	DESIGNER	CLIENT	TOOL	COLORS USED	PRINTER INFO
Efrat Rafaeli Design	Efret Rafaeli	Efret Rafaeli	Southern Exposure	Adobe Illustrator	Warm Red PMS 396	Oscar Printing

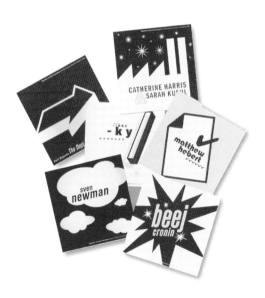

DESIGN FIRM	DESIGNER	CLIENT	TOOL	COLORS USED
Efrat Rafaeli Design	Efrat Rafaeli	Southern Exposure	Adobe Illustrator	PMS 212 PMS 3965

DESIGN FIRM
Burd & Patterson

ART DIRECTOR
Trenton Burd

DESIGNER
Trenton Burd

CLIENT
Field Paper
Company

TOOLS
Adobe Photoshop
Adobe Illustrator
QuarkXPress

PAPER/MATERIAL
Fraser Genesis

COLORS USED
Black
PMS 5773

PRINTER INFO
Purcell Printing

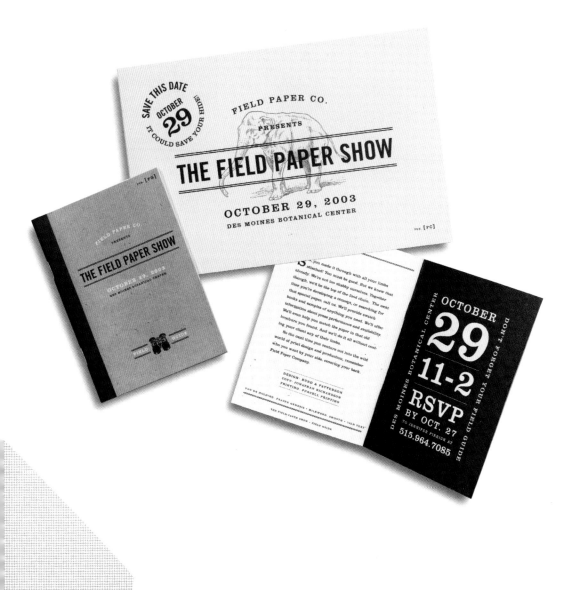

DESIGN FIRM	ART DIRECTOR	DESIGNER	CLIENT	TOOL	PAPER/MATERIALS	COLORS USED	PRINTER INFO
	Jennifer Jerde	Aaron Cruse	Elixir Design	QuarkXPress	Exact Offset Carbonless Copy Paper	Black Various Stamping Inks	Lauretta Printing

DESIGN FIRM	ART DIRECTOR	DESIGNER	CLIENT	TOOL	PAPER/MATERIALS	COLORS USED	PRINTER INFO
Elixir Design	Jennifer Jerde	Nathan Durrant	Elixir Design	QuarkXPress	Cougar Opaque Domtar Opaque Hammermill Via	PMS 8003 Black	Hemlock Printers

DESIGN FIRM	ART DIRECTOR	DESIGNER	CLIENT	TOOL	PAPER/MATERIAL	COLORS USED	PRINTER INFO
B.u.L.b factory Geneva	Nicolas Robel	Michael Bartalos	B.u.L.b factory Geneva	Adobe Illustrator	Matte	PMS 397 Rubine Red	Offset

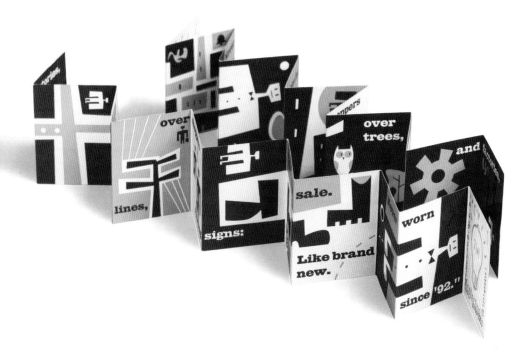

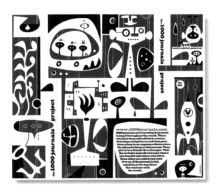

DESIGN FIRM	ART DIRECTOR	DESIGNER	CLIENT	TOOLS	PAPER/MATERIAL	COLORS USED	PRINTER INFO
Michael Bartalos	Masaya Yamaguchi	Michael Bartalos	Interform Japan	Hand Illustration Adobe Illustrator	Matte	Red Black	Offset

ART DIRECTOR	DESIGNER	CLIENT	TOOL	PAPER/MATERIAL	COLORS USED	PRINTER INFO
Cheryl Kellett	Stuart Morey	Stuart Morey Cheryl Kellett	QuarkXPress	Munken Lynx 130g	Black PMS Cool Gray 1	GKK Print

DESIGNER WEDDING®
Invitation

DESIGNER WEDDING®
Ceremony

Mr Stuart Morey and Miss Cheryl Kellett
request the pleasure of your company at
their marriage ceremony at The Parish
Church of St. Oswald's, The Green,
Guiseley, Leeds on Sunday 7th July 2002
at 12.00 noon.

And afterwards, at Egerton House Hotel,
Blackburn Road, Egerton, Bolton,
Greater Manchester.

A coach service will be provided on the day
of the ceremony. It will take guests from
Egerton House Hotel to the Church in
Guiseley and back to the reception after
the service. The coach will leave from the
car park of Egerton House Hotel on the
morning of Sunday 7th July 2002 at
10.00am sharp. Please do not be late
if you wish to use this service.

For those people wishing to make their own
travel arrangements, directions to the Hotel
and Guiseley can be found overleaf.

RSVP in writing by 1st June 2002 to:
Mr & Mrs P Kellett,
809 St. Helens Road,
Over Hulton, Bolton,
Greater Manchester BL5 1AS

DESIGNER WEDDING®
Confetti

Tear off and throw
enthusiastically on
the big day"

NOTE: The filler separates that confetti should not be thrown until outside of the church grounds. Thank you.

CONFETTI White	CONFETTI White	CONFETTI White	CONFETTI White	CONFETTI White	CONFETTI White
CONFETTI White	CONFETTI White	CONFETTI White	CONFETTI White	CONFETTI White	CONFETTI White
CONFETTI White	CONFETTI White	CONFETTI White	CONFETTI White	CONFETTI White	CONFETTI White
CONFETTI White	CONFETTI White	CONFETTI White	CONFETTI White	CONFETTI White	CONFETTI White
CONFETTI White	CONFETTI White	CONFETTI White	CONFETTI White	CONFETTI White	CONFETTI White
CONFETTI White	CONFETTI White	CONFETTI White	CONFETTI White	CONFETTI White	CONFETTI White
CONFETTI White	CONFETTI White	CONFETTI White	CONFETTI White	CONFETTI White	CONFETTI White

COLOR FINDER

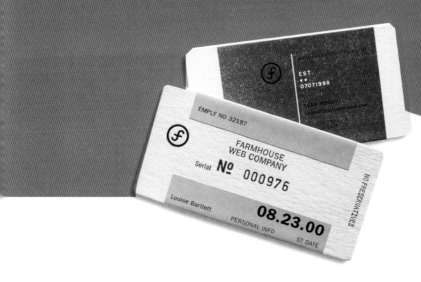

find the two-color combinations that work for you

pyramid electric co
record cover

DESIGNER
Brian Gunderson

CLIENT
Secretly Canadian

COLORS USED
PMS 604
PMS 440

national campaign against
youth violence poster

DESIGNERS
Joel Templin
Gaby Brink
Erik Johnson
Felix Sockwell

CLIENT
National
 Campaign
 Against
 Youth Violence

COLORS USED
PMS 471
Black

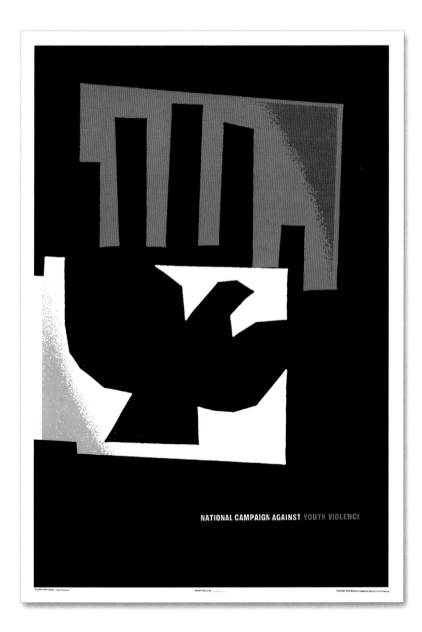

oakland a's advertising

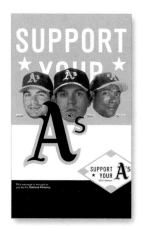

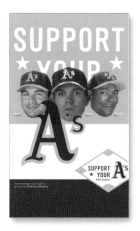

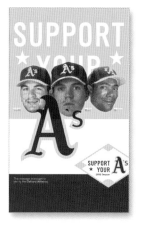

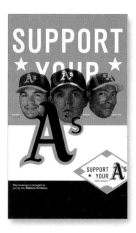

DESIGNER
Brian Gunderson

CLIENT
Foot Cone &
Belding

COLORS USED
PMS 122
PMS 342

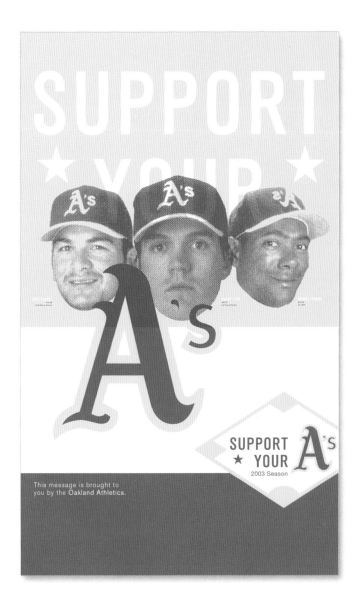

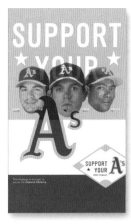

336

DESIGNER
Joel Templin

CLIENT
Phoenix Pop

COLORS USED
PMS 144
Black

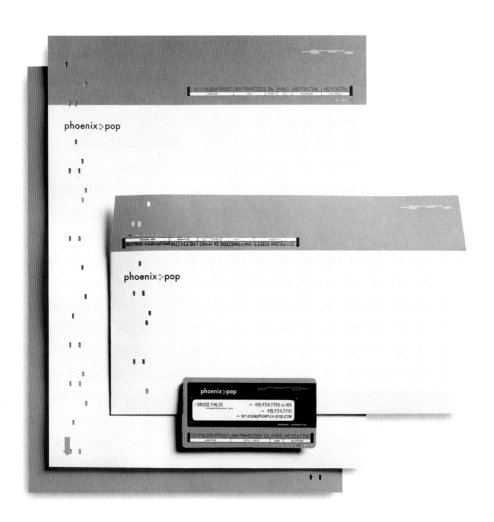

HEMISPHERES magazine

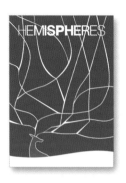
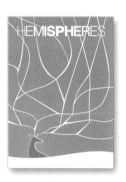
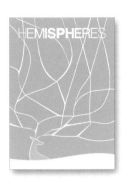
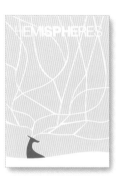
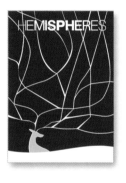
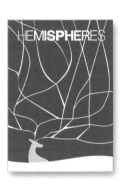

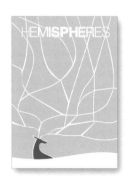
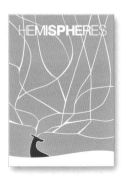

DESIGNER
Marius Gedgaudas

CLIENT
United Airlines

COLORS USED
PMS 1805
PMS 7519

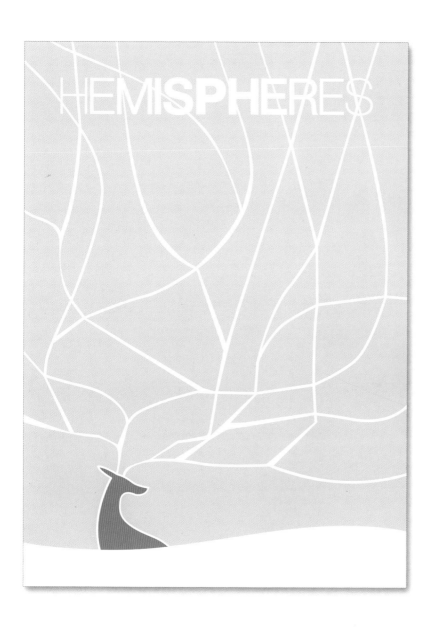

DESIGNER
Brian Gunderson

CLIENT
Art Real

COLORS USED
PMS 639
PMS 367

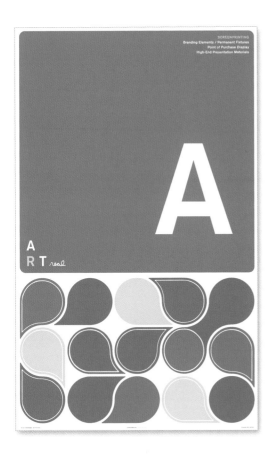

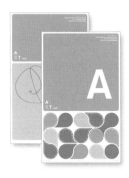

DESIGNER
Brian Gunderson

CLIENT
Farmhouse Web
Company

COLORS USED
Business cards:
PMS 152 / Black
PMS 106 / Black
Stationery:
PMS 354 / Black

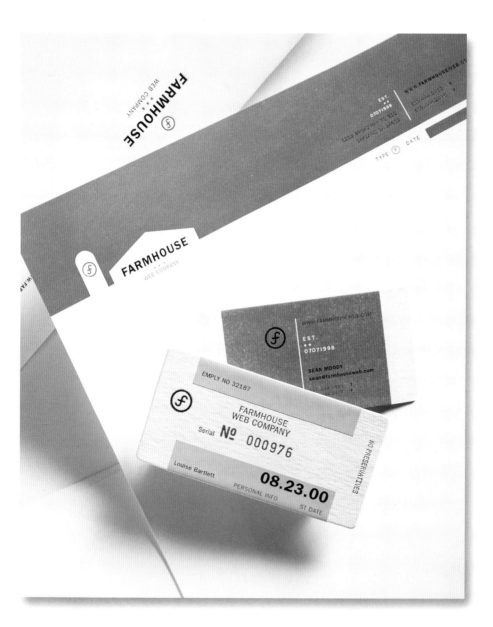

farmhouse stationery

T.B. D. façade

DESIGNERS
Joel Templin
Gaby Brink

CLIENT
Templin Brink
 Design

COLORS USED
PMS 382
Black

DIRECTORY OF CONTRIBUTORS

@radical.Media
435 Hudson Street 6F
New York, NY 10014
212.462.1568
raf@radicalmedia.com
[166]

50,000 Feet, Inc.
1700 West Irving Park Road
Suite 110
Chicago, IL 60613 USA
773.529.6760
petersen@50,000feet.com
[285]

8 Blu
175 Peralta Avenue
San Francisco, CA 94110 USA
patrickn@buderengel.com
[214]

9MYLES, Inc.
2817 Turnbull Street
Oceanside, CA 92054 USA
858.344.8619
fuel@9myles.com
[207]

A Day In May Design
3053 Fillmore Street PMB 182
San Francisco, CA 94123 USA
415.614.0005
design@adayinmay.com
[12, 64–65, 128]

Actia
7 Rue édouard Nortier
Neuilly/Seine 92200
France
33.014.738.2905
a.dermenghem@actia.asso.fr
[158]

Adi Stern Design
39 Ahad Ha'am Street
Tel Aviv 65205
Israel
972.3.5601395
adi@adistern.co.il
[231]

Aesthetic Apparatus
27 North 4th Street, #301
Minneapolis, MN 55401 USA
612.339.3345
dan@aestheticapparatus.com
[252, 269, 272, 273, 275, 279]

ALR Design
3007 Park Avenue #1
Richmond, VA 23221 USA
804.359.2697
noah@alrdesign.com
[52, 129]

Alterpop
1001 Mariposa Street, #304
San Francisco, CA 94107 USA
415.558.1615 x204
chris@alterpop.com
[205]

Ames Design
1735 Westlake Avenue N, #201
Seattle, WA 98109 USA
206.516.3020
barry@speakeasy.net
[242, 289]

Amy Knapp Design
54 Scenic Avenue
San Anselmo, CA 94960 USA
415.482.0541
amyknappdesign@earthlink.net
[39]

And Partners, Inc.
156 Fifth Avenue
Suite 1234
New York, NY 10010 USA
212.414.4700
david@andpartnersny.com
[210, 214]

Anvil Graphic Design
2611 Broadway
Redwood City, CA 94063 USA
650.261.6095
www.hitanvil.com
aratliff@hitanvil.com
[122]

Arkzin D.O.O.
Ilica 176/1
Zagreb, HR-1000
Croatia
dejankrsic@zg.tel.hr
[102, 237]

The Art Dump/Ohio Girl Design
22500 South Vermont
Torrance, CA 90502 USA
310.663.5080
andy@ohiogirl.com
[275, 296, 303]

Aufuldish & Warinner
183 The Alameda
San Anselmo, CA 94960 USA
415.721.7921
bob@aufwar.com
[56–57, 240]

Auston Design Group
101 So. Coombs Street
Studio P
Napa, CA 94559 USA
707.226.9010
auston@austondesign.com
[25, 165]

B12
10334 E. Pershing Avenue
Scottsdale, AZ 85206 USA
480.614.9772
dave@btwelve.com
[211]

Bamboo
119 North 4th Street, #503
Minneapolis, MN 55401 USA
612.332.7100
anna@bamboo-design.com
[228]

BBM&D
2873 Pierpont Blvd.
Ventura, CA 93001 USA
805.667.6671
805.667.6674
jleslie@bbmd-inc.com
[124–125]

BBK Studio
648 Monroe Avenue NW
Grand Rapids, MI 49506 USA
616.459.4444
yang@bbkstudio.com
[235, 311]

BC Design
116 S. Washington Street, #2
Seattle, WA 98104 USA
206.652.2494
info@bcdesign.com
[196, 217, 264, 265, 297, 299, 304, 306, 318]

Becker Design
225 E. St. Paul Avenue
Suite 300
Milwaukee, WI 53154 USA
414.224.4942
www.beckerdesign.net
[38]

Big Giant
1631 NW Thurman Street
Suite 150
Portland, OR 97209 USA
503.221.1079
jwilson@big-giant.com
[202]

Bløk Design
Atlixco 50 B. La Condesa
Delegacion Cuahutemoc 06140
Mexico
52.55.5553.5076
blokdesign@att.net.mx
[32, 67, 68–69, 152–153, 235]

Blue River
The Foundry
Forth Banks
Newcastle Upon Tyne
UK
44(0)191.261.0000
simon@blueriver.co.uk
[313]

Bowhaus Design Groupe
340 N. 12th Street
Suite 314
Philadelphia, PA 19107 USA
215.733.0603
info@bowhausdesign.com
[33]

Burd & Patterson
2223 Grand Avenue
Unit 4
West Des Moines, IA 50265 USA
515.222.3162
trenton@burdandpatterson.com
[324]

Cabra Diseño
417 14th Street
San Francisco, CA 94103 USA
415.626.6336 x16
wes@cabradiseno.com
[97–99]

Cahan & Associates
171 2nd Street
5th Floor
San Francisco, CA 94105 USA
415.621.0915
info@cahanassociates.com
[22–23, 54–55, 322]

Catalyst Studios
126 North 3rd Street
Suite 200
Minneapolis, MN 55401 USA
612.339.0735
design@catalyststudios.com
[201, 218]

Character
487 Bryant Street
3rd Floor
San Francisco, CA 94107 USA
415.227.2100
patriciae@charactersf.com
[194, 206]

Cheevers
319 SW Washington
Suite 1200
Portland, OR 97204 USA
503.228.5522
www.cheevers.com
[112–113]

Chen Design Associates
589 Howard Street
4th Floor
San Francisco, CA 94105 USA
415.896.5338
info@chendesign.com
[170–171, 172–173, 174, 175, 176–177, 284]

Cheng Design
505 14th Avenue East, #301
Seattle, WA 98112 USA
206.328.4047
karencheng@mindspring.com
[227, 236]

Choplogic
2014 Cherokee Parkway
Louisville, KY 40204 USA
502.451.0383
[20]

Cronk Shepard Design
376 President Street
No. 2-L
Brooklyn, NY 11231 USA
718.246.2315
wendy_cronk@yahoo.com
[322]

Dead Letter Type
351 9th Street #203
San Francisco, CA 94103 USA
415.621.4508
aaron@deadlettertype.com
[31, 138]

Decker Design
14 West 23rd Street
Third Floor
New York, NY 10010 USA
212.633.8588
lyndad@deckerdesign.com
[30]

Demo Design
2114 North Spaulding, #3
Chicago, IL 60647 USA
773.289.4749
justin@demo-design.com
[257]

Design Asylum Pte Ltd
46B Club Street S (069 423)
Singapore
65.324.8264
chris@lunaticsatwork.com
[150, 151]

Design Machine
648 Broadway
New York, NY 10012 USA
212.982.4289
gelman@designmachine.net
[270]

Did Graphics Inc.
10 Palizi Avenue
Tehran 1557974611
Iran
98.21.875.0217
art-director@didgraphics.com
[255, 276, 286]

Drive Communications
133 West 19th Street
Fifth Floor
New York, NY 10011 USA
212.989.5103
mail@drivecom.com
[34, 136]

Duffy and Partners
50 South Street
Suite 2800
Minneapolos, MN 55402 USA
612.758.2495
www.duffy.com
[200, 208, 221, 302, 306, 307]

Efrat Rafaeli Design
758 San Jose Avenue, #C
San Francisco, CA 94110 USA
415.826.0190
efratrafaeli@earthlink.net
[323]

Elixir Design
2134 Van Ness Avenue
San Francisco, CA 94109 USA
415.834.0300
kp@elixirdesign.com
[13, 21, 24, 36, 137, 160, 212, 325]

Ellen Bruni-Gillies Design
16 Elm Avenue
Kentfield, CA 94904 USA
415.482.8786
[120]

Emery Vincent Design
Level 1, 15 Foster Street
Surry Hills, NSW 2010
Australia
61.2.9280.4233
sharon.nixon@evd.com.au
[229]

Enspace, Inc.
3800 Lakeside Avenue
Unit #200
Cleveland, OH 44114 USA
216.431.2929
jenn@enspacedesign.com
[259]

Flat
391 Broadway
3rd Floor
New York, NY 10013 USA
646.613.8833 x13
tsia@flat.com
[311]

Flux
601 Fourth Street
Suite 117
San Francisco CA 94107 USA
415.974.5034
barretto@fluxstudio.com
[18, 42, 43, 132–133]

Form Fünf
Graf Moltke Str. 7
Bremen 28203
Germany
49.421.70.3074
bastian@form5.de
[27–29]

Friedhelm Plassmeier
Danziger Strasse 6
Brakel
Westfalia 33034
Germany
49.5.272.8275
[88]

Gardner Design
3204 E. Douglas
Wichita, KS 67208 USA
316.691.8808
bill@gardnerdesign.net
[305]

Gee + Chung Design
38 Bryant Street Suite 100
San Francisco, CA, 94105 USA
415.543.1192
earl@geechungdesign.com
[16]

General Public, Inc.
911 Western Avenue
Suite 305a
Seattle, WA 98104 USA
206.264.9301
hello@generalpublic.us
[296, 297]

Gillespie Design Inc.
32 W. 31st Street
Studio 7
New York, NY 10001 USA
212.239.1520
maureen@gillespiedesign.com
[70]

Grady McFerrin
115 Greenpoint Avenue, #B1
Brooklyn, NY 00222 USA
718.609.9055
grady@gmillustration.com
[261, 267, 320, 321]

Hat-Trick Design Consultants
3 Morocco Street
3rd Floor
London SE1 3HB UK
44.020.7403.7875
[204, 224]

Hausgrafik
Schöneggstrasse 5
8004 Zürich
Switzerland
41.79.204.16.50
info@hausgrafik.ch
[267, 280]

Heads Inc.
594 Broadway, #12035
New York, NY 10012 USA
212.941.5970
info@headsinc.com
[193]

The Heads of State
P.O. Box 2366
Philadelphia, PA 19103 USA
info@theheadsofstate.com
[281]

Homespun Design
1010 D Street
Petaluma, CA 94952 USA
707.766.8058
maniscal@pacbell.net
[121]

Hornall Anderson Design Works
1008 Western Avenue
Seattle, WA 98104 USA
206.467.5800
c_arbini@hadw.com
[319]

Hybrid Design
540 Delancey Street, #303
San Francisco, CA 94107 USA
415.227.4700
brian@hybrid-design.com
[203, 279, 303]

Igor Masnjak Design
L'industrie 3
Lausanne
Vaud 1005
Switzerland
41.79.681.7354
igor.masnjak@bluewin.ch
[58–63]

Imagehaus
2311 Wayzata Boulevard South
Minneapolis, MN 55405 USA
612.377.8700
info@imagehaus.net
[198–199]

Jason Schulte Design
1818 Lyon Street
San Francisco, CA 94115 USA
415.447.9850
office-sf@earthlink.net
[298, 310]

Jeanne Macijowsky Designs
5426 Hermit Terrace
Philadelphia, PA 19128 USA
215.509.7364
jmacijowsky@hotmail.com
[26]

Jennifer Sterling Design
P.O. Box 475428
San Francisco, CA 94147 USA
415.621.3481
jsterling@jsterlingdesign.com
[108, 109, 162–163]

José J. Dias Da S. Junior
Rua Nilza M. Martins, 340/103
Sao Paulo 05628-010
Brazil
55.11.9603.5022
jjjunior1@ig.com.br
[19]

karlssonwilker inc.
536 6th Avenue
2nd Floor
New York, NY 10011 USA
212.929.8004
[202]

Kevin Clarke Design
71 Moss Street
San Francisco, CA 94103 USA
415.255.6240
revkev24@earthlink.net
[301]

Kilter
1090 Bradley Street
St. Paul, MN 55101 USA
651.330.4471
tolson@clynch.com
[233, 278]

Kinetik Communication Graphics
1436 U Street NW
Suite 404
Washington, DC 20009 USA
202.797.0605
sam@kinetikcom.com
[134, 135]

KO
6300 Avenue du Parc
Bureau 420
Montreal, QC H2V 4H8
Canada
514.278.9550
suzanne.baril@kocreation.com
[44–45, 46–47, 71, 209]

Kolegram Design
32 St. Joseph Boulevard
Gatineau QC J8Y 3V8
Canada
819.777.5538
mike@kolegram.com
[228, 245]

KROG
Krakovski Nasip 22
1000 Ljubljana
Slovenia
386.1.426.5761
edi.berk@krog.ai
[123]

Liquid Agency Inc.
448 S. Market Street
San Jose, CA 95113 USA
408.850.8836
vincent@liquidagency.com
[226]

Liska & Associates
515 N. State Street
23rd Floor
Chicago, IL 60610 USA
312.644.4400
steve@liska.com
[164]

Love Communications
533 South 700 East
Salt Lake City, UT 84102 USA
801.519.8880
pwood@lovecomm.net
[48–51]

Luba Lukova Studio
31-05 Crescent Street, No. A
Long Island City, NY 11106 USA
718.956.1045
luba@lukova.net
[254, 282]

Lure Design Inc.
833 Highland Avenue, Suite 110
Orlando, FL 32803 USA
407.835.1699
jeff@luredesigninc.com
[15, 92, 93, 94–95, 96, 100, 101, 140–141, 148, 149]

MATTER
1614 15th Street
Fourth Floor
Denver, CO 80202 USA
303.893.0330
www.matter.ws
rick.griffith@matter.ws
[114, 115, 144]

Manifesto Press
116 Pleasant #2245
Easthampton, MA 01027 USA
413.529.0009
bryan@manifestopress.com
[314]

Methodologie
808 Howell Street Suite 600
Seattle, WA 98101 USA
206.623.1044
johnc@methodologie.com
[241, 313, 314]

Michael Bartalos
30 Ramona Avenue, #2
San Francisco, CA 94103 USA
415.863.4569
mb@bartalos.com
[268, 326]

Mix Pictures Grafik
Weihermatte 5
Sempach
CH-6204
Switzerland
41.41.4600084
erich@mixpictures.ch
[116, 117]

Mo'nia
Rua José Rocha
985 R/CH, Mafamude
Vila Nova De Gaia
4430-122
Portugal
351.22.379.2295
sandramonia@hotmail.com
[72–73]

Modern Dog
7903 Greenwood Avenue N
Seattle, WA 98103 USA
206.789.7667
bubbles@moderndog.com
[266, 271, 280]

Monster Design
P.O. Box 938
Kirkland, WA 98083 USA
425.828.7853
info@monsterinvasion.com
[126]

Morla Design
463 Bryant Street
San Francisco, CA 94107 USA
415.543.6548
www.morladesign.com
[84–87]

Mucca Design
315 Church Street Fourth Floor
New York, NY 10013 USA
212.965.9821
info@muccadesign.com
[53, 161]

Nassar Design
11 Park Street
Brookline, MA 02446 USA
617.264.2862
nnassar@shore.net
[14, 17, 80, 130, 145]

Nicholas Associates
213 West Institute Place
Suite 704
Chicago, IL 60610 USA
312.951.1185
nicholas@nicholasassociates.com
[242]

Nike Brand Design
One Bowerman Drive
Beaverton, OR 97005 USA
503.532.6600
heather.amuny@nike.com
503.671.6453
julie.freeman@nike.com
[284]

Niklaus Troxler Design
Postfach
Willisau CH-6130
Switzerland
41.41.970.2731
troxler@troxlerart.ch
[104, 105, 106, 288]

Ostrauh Design Studio
Jushkova 14a – 10
Krasnoyarsk 660113
Russia
7.3912.474.105
privet@ostrauh.com
privet@krsmail.ru
[230]

Paprika
400 Laurier Street West
Espace 610
Montreal, QC
Canada
514.276.6000
joanne.lefebure@paprika.com
[219]

Peñabrand
10 Liberty Shipway #300
Sausalito, CA 94965 USA
415.337.1512
luis@penabrand.com
[200]

Pensaré Design Group
729 15th Street NW
Second Floor
Washington, DC 20005 USA
202.638.7700 x330
mev@pensaredesign.com
[248]

Power Graphixx
2-25-5 Kilazenzoku
Oia-ku
Tokyo 145-0062
Japan
81.03.3729.1838
support@power-graphixx.com
[192, 219, 221]

Public
10 Arkansas Street
Suite L
San Francisco, CA 94107 USA
415.863.2541
foreman@publicdesign.com
[66, 127, 205, 216, 234, 239]

Pylon Design Inc.
445 Adelaide Street West
Toronto ON M5V1T1
Canada
416.504.4331
scott@pylondesign.ca
[35, 146, 147, 154]

R2 Design
Praceta D Nuno Álvares
Pereira 20 2 BX
4450 218 Matosinhos
Portugal
351.22.938.6865
info@rdois.com
[195, 216]

Ramona Hutko Design
4712 South Chelsea Lane
Bethesda, MD 20814 USA
301.656.2763
[252]

Red Alert Visuals
2455 Folsom Street
San Francisco, CA 94110 USA
415.642.9803
jason@redalertvisuals.com
[110–111]

reddingk
1668 West Boulevard
Los Angeles, CA 90019 USA
213.857.5326
query@reddingk.com
[246, 247, 262, 263]

Sagmeister, Inc.
222 West 14th Street
New York, NY 10011 USA
212.647.1789
stefan@sagmeister.com
[74–77, 78–79, 139]

Sandstrom Design
808 SW 3rd Avenue
Suite 610
Portland, OR 97204 USA
503.248.9466
jennifer@sandstormdesign.com
[294, 295, 301]

Savage Design Group, Inc.
4203 Yoakum Boulevard
4th Floor
Houston, TX 77006 USA
713.522.1555
psavage@savagedesign.com
[248]

Sayles Graphic Design
3701 Beaver Avenue
Des Moines, IA 50310 USA
515.279.2922
sheree@saylesdesign.com
[159]

Second Floor
443 Folsom St.
San Francisco, CA 94105 USA
415.495.3491
www.secondfloor.com
design@secondfloor.com
[131]

Setavandyar
No. 11, Entezari Street
Aftab Ave., Vanak
Tehran 19948
Iran
98.21.803.26.58
pedram@setavand-group.com
[256]

Shoehorn Design
1010 E. 11th Street
Austin, TX 78702 USA
512.478.4190
www.shoehorndesign.com
[107]

SJI Associates
1001 6th Avenue
23rd Floor
New York, NY 10018 USA
212.391.7770
jill@sjiassociates.com
[211]

The Small Stakes
410 Fairmont Avenue, #103
Oakland, CA 94611 USA
510.841.8625
info@thesmallstakes.com
[256, 277, 283]

So Design Co.
420 North 5th Street
Suite 855
Minneapolis, MN 55401 USA
612.338.5720
aaron@sodesignco.com
[195, 215, 220, 244, 316]

Sonsoles Llorens
Caspe 56, 4°
08010 Barcelona
Spain
34.934.124.171
info@sonsoles.com
[213]

Spur Design
3504 Ash Street
Baltimore, MD 21211 USA
410.235.7803
melissa@spurdesign.com
[260, 291, 315]

Stereotype Design
39 Jane Street, 4A
New York, NY 10014 USA
212.414.2744
stereotyped@excite.com
[288]

Stim
436 West 22nd Street, 4C
New York, NY 10011 USA
917.974.6985
tsamara_designer@hotmail.com
[287]

Storm Visual Communications
210 Dalhousie Street
Ottawa, Ontario K1N 7C8
Canada
613.789.0244
studio@storm.on.ca
[226, 249]

strichpunkt GmbH
Schönleinstrasse 8a
70184 Stuttgart
Germany
49.711.620.3270
info@strichpunkt-design.de
[300]

Studio 455
455 Mariposa Street
San Francisco, CA 94107 USA
415.626.0522
karin@455sf.com
[37]

Studio Graphic Mehdi Saeedi
No. 275 West Orkide Alley
Golestan Street
Esteghlal Street
End of Hengam Street
Resalat Square
Tehran 16879-83711
Iran
98.21.736.57.70
info@mehdisaeedi.com
[255, 260]

Studio International
Buconjiceva 43
Zagreb HR-10000
Croatia
385.137.60171
boris@studio-international
[90–91]

Sussner Design
212 3rd Avenue North
Suite 505
Minneapolis, MN 55401 USA
612.339.2886
inquire@sussner.com
[319]

Templin Brink Design
720 Tehama Street
San Francisco, CA 94103 USA
415.255.9295
info@tbd-sf.com
[182–189, 330, 331, 344–345,
336–337]

Tom & John: A Design Collaborative
1298 Haight Street, #5
San Francisco, CA 94117 USA
415.722.4216
tomsigu@pacbell.net
[81, 89, 243]

Turner Duckworth
164 Townsend Street, #8
San Francisco, CA 94107 USA
415.495.8691
elise@turnerduckworth.com
[156–157, 229]

Up Design Bureau
209 East William
Suite 1100
Wichita, KS 67202 USA
316.267.1546
cp@updesignbureau.com
[196, 210, 213]

University of Washington Visual
Communication Design Program
University of Washington School
of Art
Box 353440 Art Bldg Room 102
Seattle, WA 98195-3440 USA
206.685.2773
kcheng@u.washington.edu
[103]

Visual Dialogue
4 Concord Square
Boston, MA 02118 USA
617.247.3658
fritz@visualdialogue.com
[203]

Visualmentalstimuli
110 South Bedford Street
Carlisle, PA 17013 USA
717.243.3202
dkasparek@messiah.ed
[259]

Voice
217 Gilbert Street
Adelaide, SA 5000
Australia
61.8.8410.8822
info@voicedesign.net
[241]

Werner Design Werks
411 1st Avenue N #206
Minneapolis, MN 55401 USA
612.338.2550
nelson@wdw.com
[197, 209, 238, 274, 290, 317]

what!design
119 Braintree Street
Allston, MA 02134 USA
617.789.4736
damon@whatweb.com
[225, 253, 312]

Williams Murray Hamm
Heals Building
Alfred Mews
London W1P 9LB UK
44.207.255.3232
www.creatingdifference.com
[155, 167]

Wilson Harvey (Loewy)
5 High Timber Street
London EC4U 3NX
UK
44.0.20.7420.7700
paulb@wilsonharvey.co.uk
[232]

WPA Pinfold
Ex Libris
Nineveh Road, Leeds
West Yorkshire
UK
44.0.113.244.8349
hayley@wpa-pinfold.co.uk
[192, 273, 276, 327]

Zolezzi Studio
Berlin 155-B
Col. del Carmen
Del. Coyoacán
04100 Mexico City
Mexico
55.5554.3432
lourdes@zolezzistudio.com
[258]

ABOUT THE AUTHORS

CHEN DESIGN ASSOCIATES is a multifaceted visual communications firm established in 1991 that provides innovative solutions for clients in the arts, entertainment, education, healthcare, publishing, nonprofit, and technology sectors. CDA has been recognized for design excellence with national and regional awards from organizations including *HOW* magazine, *Print* magazine, and AIGA/SF. They are based in San Francisco.

TEMPLIN BRINK DESIGN was launched in 1998 by Joel Templin and Gaby Brink. Together they have developed an organic working process that inspires creative solutions to communication challenges for any company or product. Their clients include AT&T, Pixar, Oracle, Target Stores, Turner Classic Movies, 3com, American Eagle Outfitters, Levi Strauss & Co., Indian Motorcycles, Dockers Khakis, and Avaya. Templin Brink Design is based in San Francisco.